JUMP
BOOK

Philippe Halsman's

JUMP
BOOK

Introduction by Mike Wallace

HARRY N. ABRAMS, INC., PUBLISHERS, NEW YORK

To my subjects who defied gravity

Editor's Note:
In this new edition of *Philippe Halsman's Jump Book*, we have
kept Mr. Halsman's text as it was in the original 1959 edition.

Library of Congress Cataloging-in-Publication Data
Halsman, Philippe.
 Philippe Halsman's Jump book.
 Originally published: New York : Simon and Schuster,
1959.
 1. Photography—Portraits. 2. Celebrities—
Portraits. I. Title. II. Title: Jump book.
TR681.F3H353 1986 779′.2′0924 86-7910
ISBN 0-8109-2338-6 (pbk.)

Published in 1986 by Harry N. Abrams, Incorporated, New York

Times Mirror Books

Printed and bound in Japan

Introduction

By their jumps ye shall know them.

That is what Philippe Halsman discovered when he embarked upon this collection back in the 1950's.

One was flattered to be asked to jump for this celebrated artist, but nonetheless one was doubtful. What is he really up to? What does my jump say about me? Perhaps something that I'm anxious not become public knowledge? After all, I don't publish what I tell my psychoanalyst, so why tell Halsman all about myself in one revealing jump?

But that, of course, was to reckon without his persuasiveness. With humor and gentleness he challenged the unwary into the air. And in my case at least, after one or two tentative leaps, he had me casting aside caution; I went for it. The result, over thirty years ago, was a picture of uncomplicated ambition and joy. Today, I think I'd jump less eagerly. And it's not just the years that would hold me down.

But I don't think I'm alone in that. Take a look at the lissome trio—Gina Lollobrigida, Marilyn Monroe, and Brigitte Bardot—on pages 70 and 71. Would they jump that same way were they to have the chance today? I think not.

Not so for pages 62 and 63. That sextet of comedians, were they all still jumping, would demonstrate the same abandon despite the years.

Make what you will of the pair on pages 42 and 43. Richard Nixon, I think, jumps in character. Adlai Stevenson, on the other hand, would have been president if he'd campaigned the way he jumped.

The most spectacular one of all, and my favorite, is Salvador Dali, on pages 60 and 61. A stunning character sketch, an astonishing photograph, and above all an entertainment. I mean that's what jumping is all about.

MIKE WALLACE

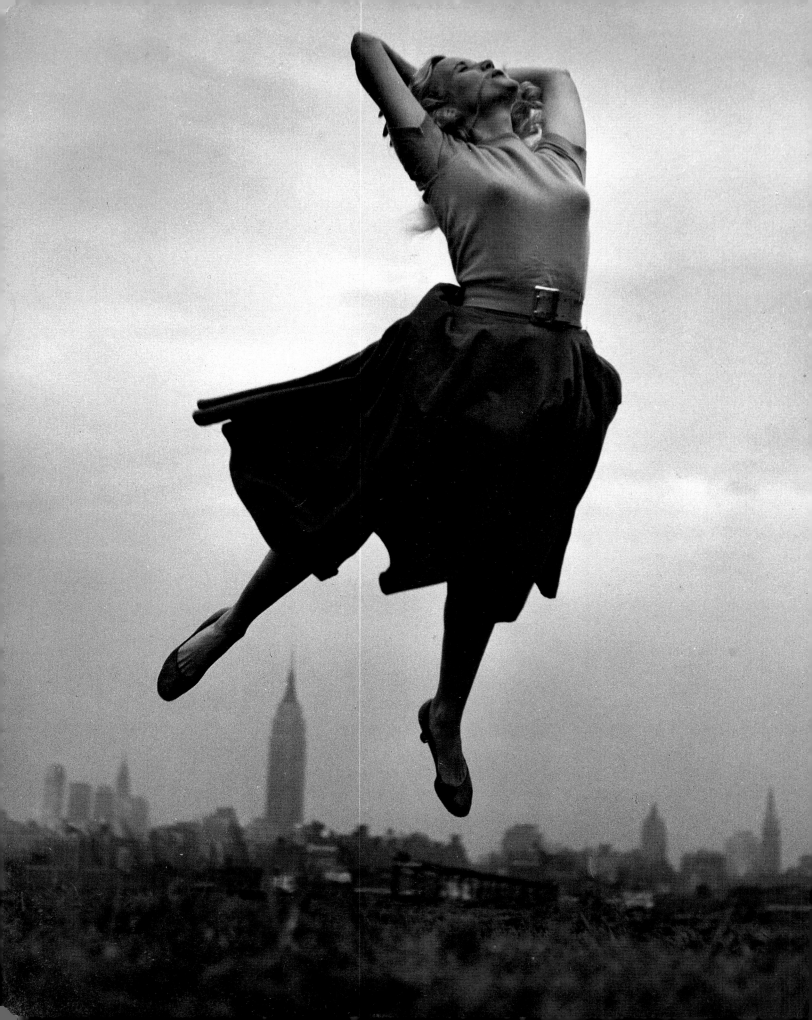

Jumpology

THE PROBLEM

This book shows 191 jumps executed by some of the most prominent and important people of our society: political figures, leaders of industry, famous scientists, artists and writers, Nobel Prize winners, judges, theologians, movie stars, TV performers and outstanding athletes. I did not select these subjects. They were the people I was commissioned to photograph in the last few years.

I must, therefore, apologize to the many illustrious and deserving men and women who were not given the opportunity to jump. In no way does it mean that they were not worthy of joining the exclusive roster of famous jumpers. It only means that by some bad fortune their names were not lately in my appointment book.

Here the thoughtful reader—thoughtless readers skip the text of a picture book—will ask himself: all this jumping is good and well, but what for? How come? These two questions show such psychological depth on the part of the thoughtful reader that, in order to do them justice, my answer must plunge deep into the art of jumping.

"To be facetious, when serious—
or to be serious, when facetious?"
—A COMPLETELY UNKNOWN PHILOSOPHER

THE MASK

Many remember Prince de Talleyrand for saying that the tongue was given to diplomats to hide their thoughts. But who will remember that author for saying that the face was given us to hide our inner self?

Our entire civilization, starting with the earliest childhood education, teaches us how to dissimulate our thoughts, how to be polite with people we dislike, how to control our emotions. "Keep smiling" or "stiff upper lip" are now categorical imperatives.

The result of this is: when we look at somebody's face, we don't know what he thinks or feels. We don't even know what he is like. Everybody wears an armor. Everybody hides behind a mask.

But one of our deepest urges is to find out what the other person is like. This curiosity to peek under other people's masks is responsible for the success of gossip magazines, of tell-it-all auto-biographies. It influences even our love life. How many romances started with the desire to penetrate the beloved's enigmatic armor? And continued with the hope that in a cataclysm of passion the mask would fall as masks do fall—alas!—in the moments of other great catastrophies.

The urge of an ordinary person to find out our innermost secrets is called nosiness and is despicable. When it is done scienti-fically by a person with an appropriate college degree, it is called psychology and is admirable. Psychologists have devised many methods to find out what we are hiding under our masks. They use psychoanalysis or hypnotism or a truth serum; they apply tests like the Rorschach test, associations test, etc. To this arsenal the au-thor is adding a new psychological tool—the jump. He calls this new branch of science "jumpology."

In a jump the subject, in a sudden burst of energy, over-comes gravity. He cannot simultaneously control his expressions, his facial and his limb muscles. The mask falls. The real self be-comes visible. One has only to snap it with the camera.

While the previous psychological methods were lengthy and costly, the jump is rapid and economical.

THE DISCOVERY

When the author is asked how he came to discover jumpo-logy, he usually answers with touching humility: "By sheer genius,

I suppose." In reality he is aware, however, that great discoveries are rarely made in a single flash of inspiration.

Who knows how many times Isaac Newton was hit by apples before he gave birth to his theory of gravitation? It is highly improbable that Archimedes discovered specific gravity the first time he took a bath.

The roots of my discovery reach into my early childhood. I was born with an intense interest in jumping. As the last photograph in this book shows, I could run, jump and turn over in the air. But six years ago the Odyssey of my own jumps stopped when I cracked my iliac.

Then came the crisis which changed everything. I was commissioned by the Ford Company to photograph, for its fiftieth birthday, the entire Ford family, the pictures to be published in *Life*, *The Saturday Evening Post* and *Look*. I went to Grosse Pointe and found that the family consisted of nine bubbling adults and eleven laughing and crying children and babies. After a cataclysmic sitting, Mrs. Edsel Ford invited the fatigued adults and the comatose photographer for a nerve-soothing drink.

Looking at the hostess, I came back to life. There was the charming matriarch of one of the great American families, and suddenly, like a pang, I felt the burning desire to photograph her jumping.

"Are you going mad, Halsman?" I asked myself. "Will you propose that she jump—a grandmother and an owner of innumerable millions of dollars?"

"You are just scared, Philippe, you white-livered coward!" I answered myself, since, unlike Hamlet, my inner conflicts tend more toward vulgar dialogues than refined soliloquies.

I winced under the insult. "Me scared? I will show you, Halsman!" and, trembling with indignation and fright, I asked Mrs. Edsel Ford, "May I take a picture of you jumping?"

I have never seen an expression of greater astonishment. "You want me to jump with my high heels?" she asked incredulously.

I explained that it was not obligatory. Mrs. Edsel Ford asked her children to excuse her and went with me to the hall. She took her shoes off and jumped gracefully a couple of times. Sud-

denly I heard the voice of Mrs. Henry Ford behind me: "May I also jump for you, Philippe?"

This was the turning point in my hard road to jumpology. My inhibitions disappeared and were replaced by faith. I realized that deep underneath people wanted to jump and considered jumping fun. From that moment, every time I photographed important people, I asked them to jump.

Soon I recognized that jumps also had a therapeutic value. When my sitters were self-conscious and tense, I asked them to jump. The mask fell. They became less inhibited, more relaxed— i.e., more photogenic.

A year and a half later I was telling René, my brother-in-law, that I already had a collection of sixty famous jumps and that I had not yet met with a refusal. René, who is hopelessly French, answered, "America is a young nation. Inside every American is an adolescent. But try to ask a Frenchman to jump. *Il te rira au nez*—he will laugh into your nose!"

The following week I had to photograph a French writer, Romain Gary, for his book jacket. Gary was a heroic flier during World War II, and one of his books won the Prix Goncourt. (He is now the French Consul in Los Angeles and his *The Roots of Heaven* and *Lady L.* are recent best sellers.)

Gary jumped for me several times. His jumps were both romantic and heroic. It looked as though, in mid-air, he was offering his chest to enemy bullets. After the sixth jump I closed my camera. Gary said, "May I please jump once more? I don't think that I have expressed myself completely."

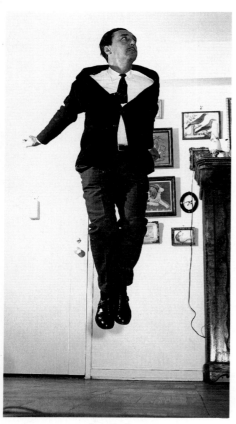

Romain Gary

OTHER JUMPERS

Many interesting things are bound to happen when one photographs jumps of extraordinary people. I remember how I photographed America's most venerated jurist, Judge Learned Hand, whose wisdom and character I have always admired. When

I asked him to jump, the judge, who was 87, answered, "Don't you think this might kill me?"

I looked at his erect posture, remembered the way the attractive girl researcher tried to flirt with him, and replied, "But, Your Honor, you are still very young."

The judge did not listen to me. He continued his thought: "After all, maybe, this is not a bad way to go...." My eyes got cloudy with tears, and I had difficulty in focusing my Rollei while photographing the judge's jump.

Although the memory of these words saddens me always anew, the picture of the jump makes me less fearful for my own old age. I hope it will mean to the judge what it means to me—a proof that the secret of eternal youth is in one's spirit.

In the fall of 1955 I was commissioned to photograph the Duchess of Windsor for the cover of the issue of *McCall's* magazine containing the first installment of her autobiography.

The newspapers had made much of her difficulties with her writers, and I found her preoccupied, showing less of the extraordinary poise that had always impressed me.

When, after the portrait sitting, I asked the Duchess to jump, she replied, "You would like that, wouldn't you?" I looked at her expectantly. She smiled and shook her head.

The issue of *McCall's* was an unprecedented success. It was completely sold out in two days. The Duchess was bombarded with requests from magazines and book publishers in all parts of the globe. I was asked to photograph the Duchess again for the jacket of her forthcoming book.

This time I found her completely changed. Her old poise had returned; she looked gay and absolutely sure of herself. At the end of the sitting the Duchess asked me, "You don't want me to jump?"

"Of course I want it," I answered, overjoyed.

The Duchess took her shoes off and jumped for my camera. Seeing this, the Duke also took his shoes off and jumped. Then, holding hands and smiling, the Duke and Duchess jumped together.

One day I went to Washington to make a color portrait of Admiral Radford, who was then the chairman of the Joint Chiefs of Staff. I was informed that he would give me an entire hour, but in the Pentagon I found, in front of the admiral's office, over half a dozen other photographers waiting with their paraphernalia. I recognized Arthur Rothstein from *Look*, representatives of other magazines and the photographers from UP and AP. I was allowed twelve minutes for my sitting and was the first one to enter.

I managed to finish my portrait in twelve minutes and asked the admiral to jump. Just as he leaped, the door was swung open by the impatient photographers who resented my overstaying the allotted time by fifty seconds. A strange sight appeared in front of their unbelieving eyes.

In the sparkling glory of my multiple electronic flashes, wearing his gala uniform, Admiral Radford was suspended high in mid-air against a multicolored world map. It was a magnificent jump, denoting sportsmanship and leadership.

In New York I gave the priceless film to my most trusted assistant—my wife. She hurried into the darkroom to develop it. A quarter of an hour later I heard her crying. I rushed into the darkroom and asked, "Yvonne, what happened?"

"Look!" she sobbed and showed me the developed film. It was blank—no image.

I inspected my camera. It had been checked by my repairman only a few days before. I saw that he had moved the synchronization lever from X to M. My camera had taken the picture 20 milliseconds after the electronic flash.

I felt like crying, too. I had never missed with any of my jumping pictures. And here one of the most unusual ones was irrevocably lost.

Not long ago I made a portrait of the famous photographer Captain Edward Steichen. He began as a painter, but one day decided to turn to photography.

Photographers start out simply by going out and taking pictures. But not the thorough Steichen. He stopped painting, and for months he photographed the same cup and saucer, studying the

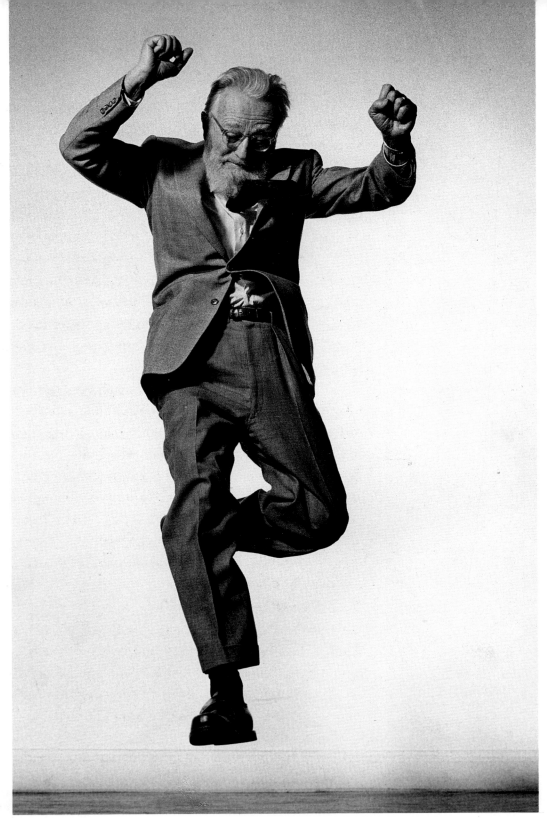

Capt. Edward Steichen

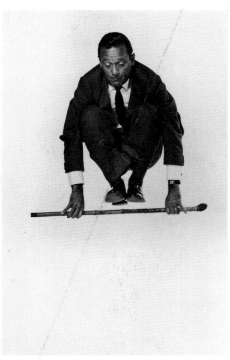

William Holden

influence of light, of perspective, etc. Only after this did he start his career as a photographer.

People who jump for me do it simply by leaping upward. But not the thorough Steichen. He asked me whether he could first take a running start. My photograph shows the jump which followed.

The strangest experience occurred with General Omar Bradley, who is now chairman of the board of the Bulova Company. General Bradley gave a fine, spectacular jump, but after accomplishing it he specified that it was not for publication. Of all the jumpers I have photographed he was the only one to make this request.

I remember also photographing the former American High Commissioner for Germany, John J. McCloy, who returned from Germany to become the president of the Chase Manhattan Bank. When I asked him to jump he said, "I had a ski accident in Europe. My leg has been out of the cast for only a week."

"In that case," I said with deep compassion, "don't try to jump high."

There was nothing to gain by this jump, but Mr. McCloy did not spare any effort, and made a terrific jump. This jump explained to me why the man was so successful: nothing could dampen his boundless energy.

Several years later I had a similar experience with Philip Reed, chairman of the board of General Electric. His spectacular career started when, after receiving his engineering degree, the newly married young man took his law degree by studying at night while working as an engineer by day.

Mr. Reed jumped with such energy that I remarked, "Now, I understand the reason for your amazing success. You put everything you have into even your least important task."

"You see this in my jump?" asked Mr. Reed, surprised. "Yes, I always put myself entirely into whatever I do. The strange thing," he added with a wink, "is that one never knows who is watching."

When I asked the movie star Bill Holden to jump, his eyes

shone and he exclaimed, "You are a man after my own heart!" He asked for a cane and, holding it with two hands, proceeded to jump over it.

It was dazzling acrobatics, and the task of getting the picture in the precise hundredth of a second when his feet just cleared the cane was almost as difficult.

When Jack Dempsey jumped for me, he skipped an imaginary rope, as if he were in training for a fight.

I was surprised to see the writer John Steinbeck jump the same way, but then I remembered that in his youth he was a prize fighter. I suspect that, rereading his manuscripts, he at times might murmur to himself, "This chapter needs a left hook."

I was even more surprised when, before leaping, the British actor Maurice Evans asked for a jump rope and started to skip with great skill. Strange that two non-actors used an imaginary prop, but an actor needed the real thing.

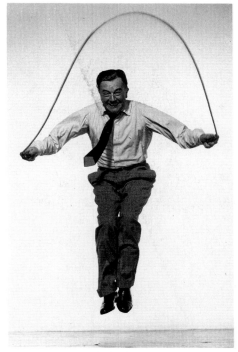

Maurice Evans

When Marilyn Monroe jumped in my studio, she bent her knees and, like a little girl, threw her legs backward. The legs disappeared and, in the moment of the picture, I saw a truncated torso. Without realizing the excellence of this image, I complained that I could not see her legs.

"Marilyn," I said, "try to express your character a little more."

"You mean that my jump shows my character?" she asked hesitantly.

"Of course," I answered. "Please try it once more."

But Marilyn stood there, pale, as though paralyzed, unable to jump. After a painful pause which seemed like an eternity, I spoke up: "All right, Marilyn, let us do some other pictures."

One day I decided to ask my friend Harold to jump. His last name is Lloyd, and he is one of the three immortal American film comedians—the other two being, of course, Charlie Chaplin and Buster Keaton. Everybody remembers Lloyd hanging from the hand of a clock on a high tower, to make a hundred million spectators shriek and laugh. On his next visit to New York, I asked him to jump.

Hugh Gaitskell
Leader of the British Labour Party

Standing in front of my camera, he asked enthusiastically, "Do you want me to jump and to land on my shoulder?"

I thought of his grandchild, and I weakened, to my everlasting shame as a photographer.

"Harold," I said, "please land on your feet! I'd rather have a healthy friend than an unusual photograph."

TO JUMP OR NOT TO JUMP

People often inquire how come I did not ask Churchill to jump. Unfortunately I photographed him B. J. (Before Jumpology).

On my next visit to England I found out, however, that, possibly because they are a seagoing nation, the British as a rule don't care for jumping. Lord Admiral Mountbatten made a disparaging remark about it, so I photographed him standing and sitting, but not in mid-air. Lord Bertrand Russell refused, explaining that he did not want to divulge his character. When I photographed Dame Edith Sitwell, the poor lady could, at the moment, barely walk and had difficulty in standing. I did not ask her to jump because it was obvious that the only thing Dame Edith could do well was to sit well.

Having failed with the titled crowd, I had hopes with the leaders of the Labour Party. The fiery rebel Nye Bevan threw a suspicious look at me and refused. I gave up my hopes and photographed Hugh Gaitskell without asking him to jump. After the sitting, I packed my equipment and started to leave. In the hall Gaitskell asked me with disappointment, "You don't want me to jump?" Overjoyed, I unpacked my speedlights and photographed him on the spot.

Attlee was ready to retire as the leader of the Labour Party and the rivals for his succession were Bevan and Gaitskell. There was no doubt in my mind who would win—the circumspect and basically insecure Bevan or the outgoing, dynamic Gaitskell. When it came to a showdown, Gaitskell won hands down.

A year later I was commissioned to photograph Governor Harriman, who hoped to become the Democratic Presidential nominee in the 1956 election and had just been endorsed by former President Truman. When I asked the governor to jump, he looked undecided. In a low voice he said something to an aide. In the whispered answer I caught the name of President Truman, and Harriman's face took on a worried expression. With an apologetic tone the governor said that he would have gladly jumped for me but he had to decline out of respect to the high position he occupied.

"Out of respect to the high position you hope to occupy," I translated for myself.

Two weeks later I went to Chicago to make the official campaign portrait of Adlai Stevenson. I found him most witty, exuding charm and good humor. I asked him to jump, and, with a big smile on his face, he did so several times for my camera.

"Mr. Stevenson," I said, "your most serious rival refused to jump. Do you know what it means?" I told him the story of Bevan and Gaitskell. "It means that you will win the nomination."

The convention in Chicago became the showdown between a stiffly cautious candidate and a dynamically springy one. Naturally, Stevenson won.

THE NON-JUMPERS

Yes, during my career as a jumpologist I have met with refusal from time to time. (I have already mentioned my experiences in England with Lord Mountbatten, Lord Russell and Nye Bevan.) Every time it was heart-breaking. Luckily, these incidents were extremely rare.

One evening at a ballet performance, after such an experience, the heart-broken author witnessed an entire audience bursting into a storm of applause after seeing a few spectacular jumps by André Eglevsky.

Okay, thought the author, but what is wrong with a private

jump? Why did Mr. X refuse? Is jumping indecent, degrading or too intimate?

With rare courage the author admits his knowledge of activities that fall into these categories. He can therefore authoritatively assure the worried reader that in no known civilization and at no period of history was jumping frowned upon.

So why did some people refuse to jump?

The author suspects that if there were an established custom of photographing all people seated, the same individuals who refuse to be photographed jumping would refuse to be photographed standing. Possibly they would find it indecent, degrading or too intimate.

Consequently, the author introduces the following jumpological rule: the refusal to jump is a symptom of an exaggerated fear of losing one's dignity.* It reveals a hidden, deep-seated insecurity.

All rules, however, have exceptions. The people who refused to jump for the author are of such an exceptional caliber that the author considers them as natural exceptions to this rule, and probably to many other rules, too. Therefore he will report the facts and nothing but the facts.

In the beginning, during the first two years, nobody refused to jump for the author. He began to think that to jump, like to err, was human.

But then came the day when he had to photograph a man whom he considered to be television's very marrow, the moody Ed Murrow. The man is a living legend. Everybody knows the story about CBS correspondents who founded the "Murrow Ain't God" club and how Murrow applied for membership.

The living legend refused to jump. Murrow felt slightly guilty about being uncooperative and, when he noticed the tragic despair on my face, he made me a present—a copy of his book *This I Believe*.

A year later, misfortune hit me again. I had to photograph the Secretary General of the UN, Mr. Dag Hammarskjöld, whom I found a self-conscious and difficult subject. Mr. Hammarskjöld refused to jump.

* One who has dignity cannot lose it in a jump.

My next fiasco took place in Louviers, France, where I photographed Pierre Mendès-France, whose cabinet had just fallen. Right at the beginning he asked me how many pictures I proposed to take. Careful not to frighten him by telling that I intended to take a lot, I answered, *"Une vingtaine."*

I started to shoot pictures, along with pointed questions about his role in rearming West Germany. In the middle of the sitting, instead of answering a particularly embarrassing question, Mendès-France said, "Monsieur Halsman, you just made your twentieth picture."

I started to explain that *"une vingtaine"* did not mean "twenty and not more," but that it was only an approximation and just *une façon de parler*.

"If you mention figures you must stick to them," interrupted Mendès-France. "But can one trust the word of a photographer?"

My professional pride was hurt and I answered, "At least as much as the word of a politician, *Monsieur le Président."*

There is no room to record the entire conversation, but when, five minutes and ten pictures later, I asked him to jump, the dynamic Mendès-France refused.

Is it possible that, having recently lost his post of Ministre-Président, he found it politically unwise to be photographed in mid-air?

Van Cliburn

Last year a magazine asked me to make a cover photograph of Van Cliburn. After an agonizing sitting with the famous pianist—he does not care to pose for photographers—I rearranged my speedlights, pulled out my Rollei and asked him whether he would jump for me.

Van Cliburn refused. Politely I inquired what his reasons were for not wanting to jump.

The artist put his arms behind his back, lifted his chin and said, "There is no need for explanations."

Semiautomatically my finger pressed the release and I obtained a photograph of Mr. Cliburn at this stirring moment.

A few months later an advertising agency asked me to

photograph former President Hoover and, a week later, Mrs. Eleanor Roosevelt, looking admiringly at a product the agency was advertising. I hasten to add that Mrs. Roosevelt and Mr. Hoover turned over their substantial model fees to their favorite charities.

I knew that only recently Mr. Hoover had undergone an operation and I had doubts whether I ought to approach him with my usual request. But when I saw him in his office, looking healthy and keeping four secretaries working at full speed, my sense of duty prevailed.

As soon as I finished the advertising shots, I asked President Hoover to jump. Mr. Hoover declined and explained with kindness, "You see, Mr. Halsman, I am not an actor and for me jumping would be like acting."

I was looking forward to my sitting with Mrs. Roosevelt, but one day before the sitting I received a letter from the advertising agency. They politely suggested that I not ask Mrs. Roosevelt to jump during this sitting, but wait for a future occasion.

On this sad note ends the sad tale of the refusals.

If the understanding reader considers the number of jumpers—and hundreds of unpublished jumps are still in my files—he will realize that only one or two percent of my sitters refused to jump. Strangely, only men declined. No woman I asked refused to jump.

There was only one case when I fully expected a refusal from my subject. I don't pretend to understand entirely the reasons which had prevented my aforementioned sitters from jumping, but David McDonald, the president of the United Steelworkers of America, had very valid reasons for refusing.

It was during the steelworkers' strike of 1956. Neither U.S. Steel nor the United Steelworkers wanted to give in. In the middle of this stalemate, a national magazine asked me to shoot Mr. McDonald for the cover.

After finishing my color portrait, I took my Rolleiflex out and asked Mr. McDonald to jump. There was a long silence. His two lieutenants looked at him expectantly. On Mr. McDonald's

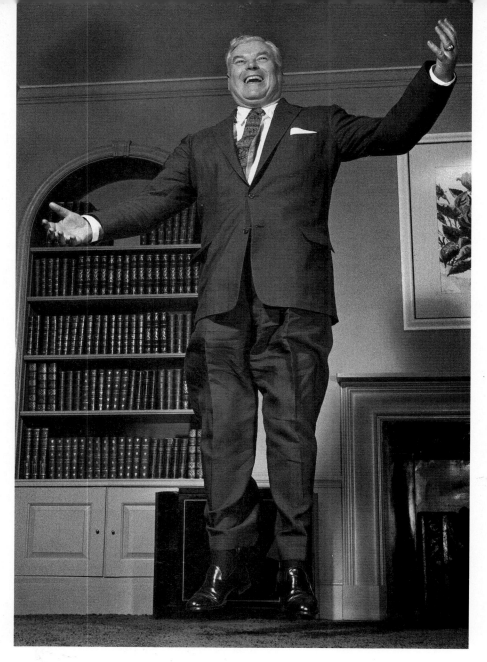

David J. McDonald
President of the United
Steelworkers of America

face I could read his thoughts. He was weighing the possibility of the appearance in the magazine of the jumping picture with an ironic caption. It would ridicule and compromise him before the entire nation.

He looked again at me. I was too proud to say that I would not sell the jumping picture, and remained silent.

David McDonald got up and said, "Okay, shoot!"

He did not even ask me not to submit the photograph to the magazine. He knew I would not do it. I remember his silence as one of the sincerest compliments I have received.

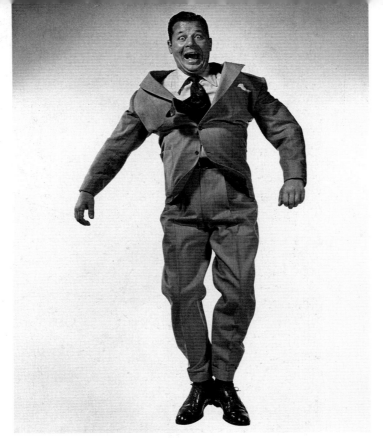

Jack Carson

The Interpretation of Jumps

Dennis Day

The author is well aware that jumpology is still a virgin territory and that he is its first pioneer. He therefore presents his findings with great and characteristic modesty and hopes that among his readers many will want to participate in the exploration of this new branch of psychology.

THE SYMBOLISM IN JUMPING

While awake and conscious, we use ideas and words as means of expression. Subconsciously, however, we express ourselves in symbols. Usually these symbols are hidden and call for discovery and interpretation. The basis of graphology, for instance, is nothing but the interpretation of the hidden visual symbols which the subject subconsciously creates in his or her handwriting.

Similarly the jumpologist searches for the hidden symbol in a jump and tries to interpret it. He will point it out, even if it seems to be farfetched or due to an accident. The father of psychoanalysis, Dr. Freud, did not believe in accidents when they concerned human behavior. He called them *Fehlleistungen* and analyzed their hidden meaning.

The photograph of hulking Jack Carson looks—perhaps by accident—as if he were jumping out of his clothes. We should not be afraid to see in it the symbol that, deep inside, he feels slender and adolescent.

When we see that the right side of Dennis Day seems accidentally to jump in one direction and the left side in another, we assume that he may have two distinctly dissimilar personalities.

When I photographed a married couple and found that in six tries they jumped out of step six times, I did not dismiss this as a mere accident, but gave it a more Freudian significance.

Often the photograph of a jump does not transmit its symbolic message immediately. A closer scrutiny will show, however, that every element in the jumper's body—his arms, his legs, the position of the body, the expression of his face—reveals definite character traits.

POSITION OF THE ARMS

Whether or not we have ever visited a Near East bazaar, we must consider our hands and arms as means of communication. Even in this temperate climate we point and we greet with them, we wave to attract attention, we threaten and we embrace with them. We use sign language, we gesticulate and people say, "Stop talking with your hands." Consequently, a person who does not use his hands and arms during a jump is a person who does not communicate.

There is, of course, the remote possibility that the jumper restrains himself on purpose, perhaps in order not to reveal himself* or because of a certain image of himself which he subconsciously expresses in his jump (e.g., a soldier at attention).

But as a general rule we can say: A jumper who does not move his arms is a person who does not like to communicate or is unable to. We call him an introvert.

Some people are psychologically unable to do anything that has no purpose. In a jump, consciously or subconsciously, they assign themselves an objective and try to reach for it. This behavior denotes purposefulness and a desire for efficiency. If the mental target is high and difficult to attain, and the jumper is trying hard to reach it with one outstretched arm, this outstretched, reaching arm becomes a definite sign of ambition.

I remember an instance where I was reluctant to apply this rule. In the Princeton Institute for Advanced Studies, Dr. J. Robert Oppenheimer jumped for me, the arm outstretched and the hand extended toward the ceiling.

"What do you read in my jump?" he asked.

Jumpology had a simple explanation for it, but I felt puzzled. I looked at Dr. Oppenheimer's Spartan study, thought of his life dedicated to science and decided that the rule was not applicable. Probably there was another motivation. "Your hand pointed upward," I hazarded, "maybe you were trying to show a new direction, a new objective."

"No," said Dr. Oppenheimer, laughing, "I was simply reaching."

*See Dr. Nahum Goldmann, page 26, who hides his hands and smiles.

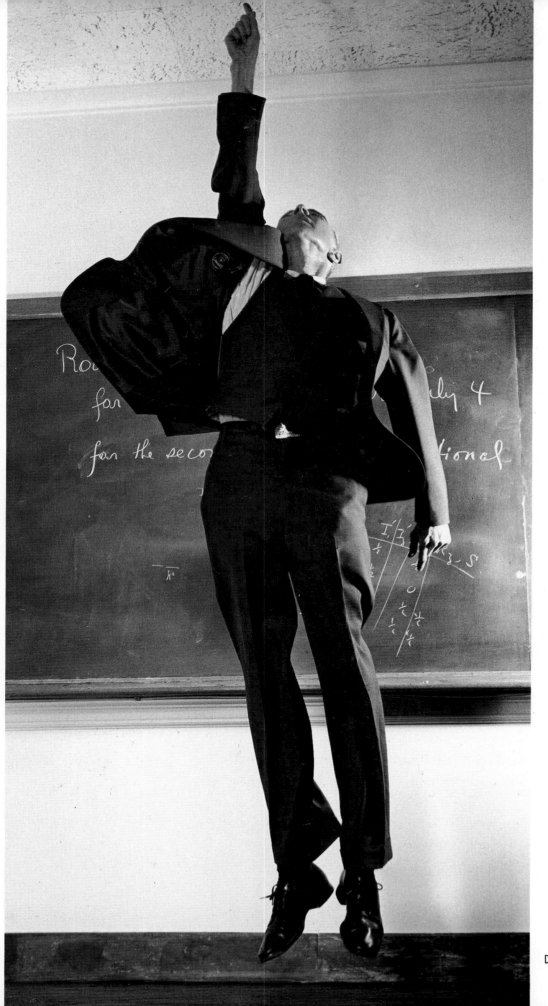

Dr. J. Robert Oppenheimer

When both arms are extended, matters become more complicated. If the arms are reaching for the ceiling, it is still a symptom of ambition. But while one outstretched arm denotes singleness of purpose and a precise and definite ambition, two lifted arms reveal a more unspecified ambitiousness, an urge to forge ahead, an aspiration to better and elevate oneself.

Sometimes the two lifted arms are not reaching. It seems as if the jumper were supporting something. The significance of this gesture is simple. The jumper tries subconsciously to express that he is the support of something (e.g., the sole support of his family or of his firm).

In this context it is interesting to observe that the majority of the industry leaders, especially the ones who reached the top the hard way, jump with their arms lifted.

Sometimes the arms are lifted in a gesture intended to draw attention to the jumper. The arms seem to say, "*Me voilà!*" or "Look at me!" The jumper's hand may even point at himself. This position of arms denotes a need for attention and an urge to impress one's fellow man.

Some people don't lift their arms when they jump, but stretch them out horizontally. This spreading of the arms is often accompanied by spreading of the legs. Making oneself as narrow and little as possible is a sign of modesty. Spreading the arms, occupying as much space as possible, signifies that the jumper has a feeling of self-importance.

Sometimes the jumper not only stretches his arms but also flexes them, as if wanting to impress us with his power. The meaning corresponds to the symbol—the jumper imagines himself strong and powerful.

Some people hold their arms as if they were trying to balance themselves in the air. This discloses a certain insecurity, a fear of acting wrongly in a new situation, a feeling that life is similar to tightrope walking.

The crossing of the arms over the chest reminds us of Napoleon's favorite pose. Its significance is that, like Napoleon, the subject has a need for reassurance and the urge to project dignity.

There are people who, with a violent swinging of arms, try to help their legs propel the body upward . This total mobilization of muscles indicates a character that is inclined to get himself totally involved in a plan or a purpose.

Often the jumper identifies himself so much with his profession that, even in a jump, he assumes its characteristic pose. In my collection we see the singer Robert Merrill seemingly sing an aria in mid-air; the conductor Efrem Kurtz conduct in a jump; and the master of ceremonies, Dick Clark, address his gum-chewing audience in mid-leap. Comedians will assume in mid-air their characteristic pose; orators and lecturers will look as if they are speaking to an audience. This of course denotes a subordination of the private life to the career.

An experienced jumpologist will also observe what the jumper does with his hands. Clenching them into a fist discloses an energetic or perhaps violent character. On the other hand, it might be only the symptom of the jumper's tenseness, which can be confirmed by observing the jumper's face and body position. This tension, of course, is a sign of the jumper's tendency to get tense also in other activities or situations, especially when they are new to him.

Conversely, holding the hands open divulges a more relaxed and mild disposition. It can, however, also originate in a lack of energy or in apathy, especially if the diagnosis is supported by the facial expression or an insufficient height of the jump.

POSITION OF THE LEGS

In the previous chapter we have shown that the arms and hands can be means of communication, but who, except some odalisque, uses legs for this purpose? The leg position in a jump, however, can communicate a lot of information about the jumper.

We learn first, of course, about the energy and dynamism of the jumper, provided that the jumper takes the test seriously. The jumpologist, however, should not jump to rash conclusions.

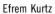
Efrem Kurtz

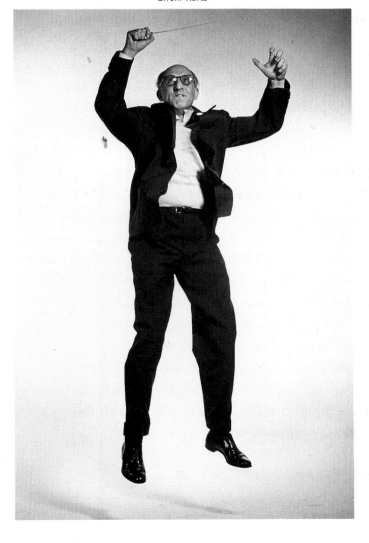

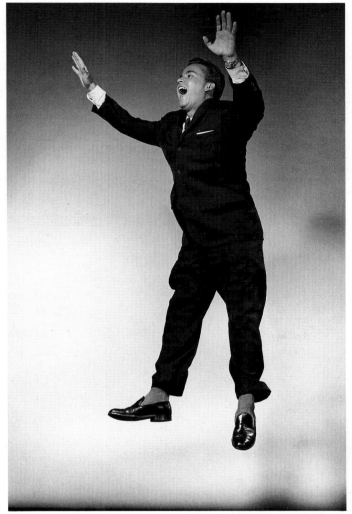
Dick Clark

Obviously it is unfair to compare the jump-energy of a young athlete and of an octogenarian intellectual. The jump of Judge Learned Hand, who was born in 1872, does not break any record, but appears highly admirable to the author, who is convinced that if he should try to jump at Judge Hand's age, he would only fall out of his wheelchair.

The next most important information is disclosed by the way the jumper holds his legs. We will first consider jumpers who do not bend their knees while jumping. Some of them hold their legs together, others spread them.

It is interesting to note that in some countries a soldier on guard duty has to keep his legs together, in other countries he has to hold them far apart. The latter looks more massive, more important and more manly. This is exactly what the jumper who keeps his legs apart tries subconsciously to project.

This explanation is valid only for the men. How about the women?

From childhood on a girl is trained to hold her legs together. Consequently, if a woman does not do so in a jump, it signifies that she subconsciously emphasizes the fact that she is a woman. It is often a sign of passion and also of independence and rebellion.

Let us stay for a while with the fair sex. Already in her childhood games the little girl learns jumping. Usually it is executed with bent knees, as in jumping a rope. When an adult woman jumps with bent knees like a little girl, it is not a mere coincidence. It shows that, at the moment of the jump, she has become again a little girl. This capability of sometimes feeling and acting like a child is characteristic of the child-woman.

What the jump test reveals about the three great love goddesses of today—Marilyn Monroe, Gina Lollobrigida and Brigitte Bardot—is highly meaningful psychologically and sociologically. It shows that they are basically child-women.

To the sophisticated reader—and only a sophisticated reader will follow me this far—this will come as no surprise. He knows that actresses become love goddesses when they provide the daydreams for millions of American males. Naturally, the average American male wants, even in his dreams, to be at ease. With a child-woman everything is easy—all play and no work. With a passionate woman-woman, however, he is afraid of finding himself inadequate.

In the not so distant past, when male superiority was not yet sufficiently undermined, a vamp like Theda Bara could become a sex queen. But in our time, which is essentially a period of

man's insecurity, the ample-bosomed child-woman, not the vamp or the passionate woman-woman, is the ideal sex goddess. This conclusion, derived from purely jumpological insight, appears to the male author as a rather sad comment on the state of our civilization. Luckily, this is only one of his minor worries.

Coming back to the people jumping with bent knees, the author wants to point out in a parenthesis that jumping humanity can be divided into two categories: one which tries to jump as high as possible and one which doesn't care. The ones who try hard have ambition, drive and the desire to impress others. The ones who don't care either don't take the jump seriously or lack ambition.

Bending the knees and throwing the legs backward, when done by a male member of the last group, is a sign of playfulness and a certain youthful disposition. But for a member of the former category (i.e., one who tries to jump high) the interpretation is entirely different.

These energetic jumpers can be divided into two main groups: the Reachers and the Crouchers. The Reacher visualizes an aim above him which he tries to reach. The Croucher imagines an obstacle which he tries to clear. The Reacher is ambitious and purposeful in his desire to elevate himself. The Croucher is competitive, and for him life is a series of obstacles to be overcome.

Thus we see that in the who-cares jumper the bending of the knees symbolizes playfulness and youthfulness, in some cases even immaturity, while the same position in an energetic jumper discloses a fighter's spirit and competitiveness.

It is interesting to note that humor in a personality manifests itself in the leg position rather than in the way the jumper uses his hands. (See jumps of Celeste Holm and Carol Channing.)

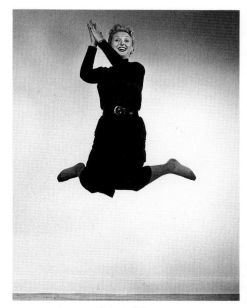

Celeste Holm

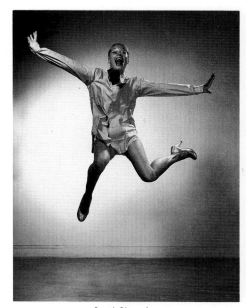

Carol Channing

BODY, FACE AND SMALL DETAILS

Not only the arms and legs permit us to read the character of the jumper. Often the body itself, through its posture, expresses character traits, such as pride, humility, exuberance, etc. Some-

times, however, the jumper expresses with his entire body not what he is but what he wants to be. Before interpreting a jump, the jumpologist must be sure that it shows the true and not the projected wish-image of the jumper.

A very important element is the facial expression of the jumper. Since a non-professional jumper approaches the jump test the way he would approach any new activity, his characteristic attitudes toward a new activity become evident.

If he jumps smiling, it signifies that he is inclined to enjoy a new activity. If he jumps intensely, with tightly set jaws, we can assume that he will embark with energy on a new enterprise. The jumper's face, and also his body and his hands, show whether he is full of tension or relaxed in a new situation.

If the jumper looks at us, we realize that the idea of the audience is present in his mind. Some jumpers are interested in watching the impression they make on the jumpologist.

Jumpers who look in the direction of the jump, preoccupied with the imaginary goal, are the people who get completely absorbed in the pursuit of their task and who are apt to forget that they are observed and judged. (This is even true for actors, because one of the principal aims of an actor is to forget that he is being observed.)

But we are all actors more or less. The jump does not always express what the jumper is. It can also express what he wants to be. The part he is acting out subconsciously in his jump might require that he look in a certain direction.

And finally there are jumpers whose eyes look as if they were directed inward. One has the impression that these people are listening to something that is happening within them. These are people who are absorbed in their own emotions, who have a strongly developed inner life.

But not only the body and the face reflect the character of the jumper; every little detail has its significance.

When, for instance, a woman takes off her shoes before jumping, she does it because she is worried that something might happen to her or to her shoes. While not taking off the shoes does not imply that the jumper never thinks of possible consequences of

her acts, their removal is a definite indication of foresight and prudence. We see that not only the jump but also everything that precedes and follows it should be observed and interpreted.

CONCLUSION

The author hopes that the preceding pages will give the thoughtful reader enough methodological material to be able to interpret, in a general way, the jumps of his friends.

The reader has probably noticed that the book does not contain any derogatory interpretation of a jump. The reason for this is twofold.

1. The author was afraid that some inexperienced reader might try to apply a derogatory interpretation to a participant in the extraordinary jumporama which follows these pages. (This the author made impossible (*a*) by careful selection of his famous jumpers and (*b*) by not including derogatory interpretations.)

2. Since the reader cannot interpret unfavorably the jumps of his friends, he will be unable to blame the author for lost friendships.

Many readers might try to experiment and explore further the field of jumpology. It is possible that they will want to share their findings with the father of this new science. The father promises to read their letters carefully, and he solemnly swears not to attempt to irritate his correspondents by replying to them.

Having laid the basis for an entirely new branch of psychology, the author modestly retires and leaves the field open to professional scientists.

He foresees a very fast exploration and growth of the new science. He will not be surprised if, in the very near future, psychologists and psychiatrists will, in urgent cases, apply, instead of the slow Rorschach, the rapid Halsman.

The necessary equipment is very simple: an electronic flash, a Polaroid camera and, of course, sufficient head room—if one does not want the patient to hit the ceiling.

To work, psychologists, and Godspeed!

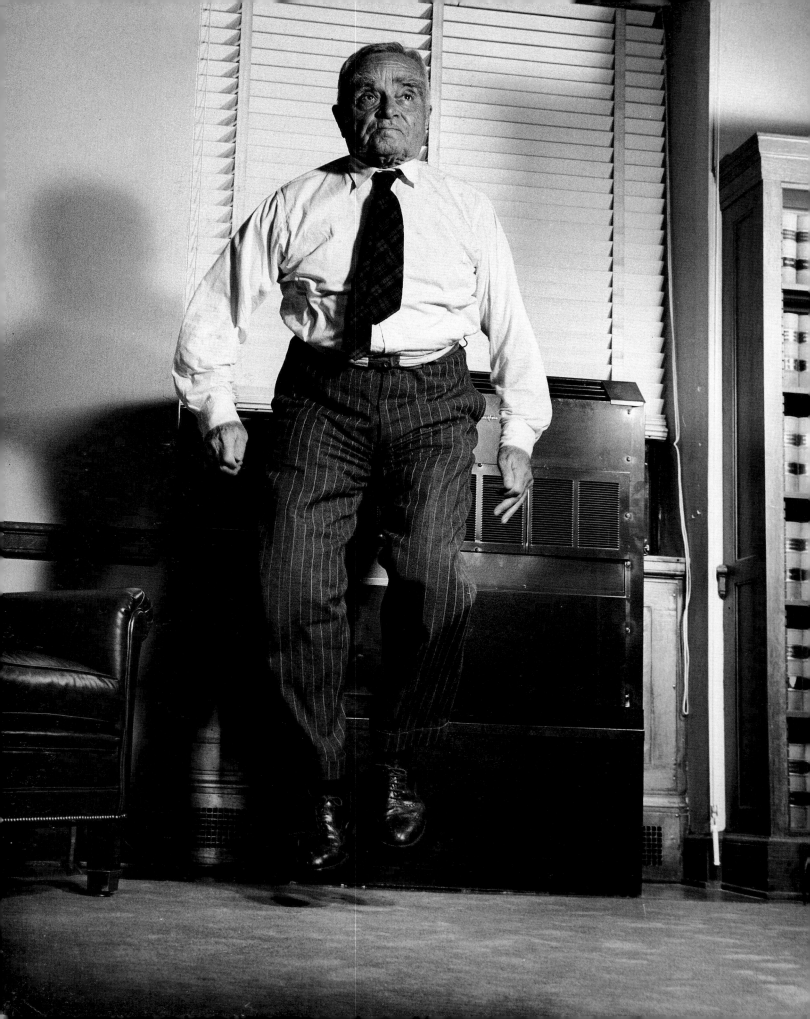

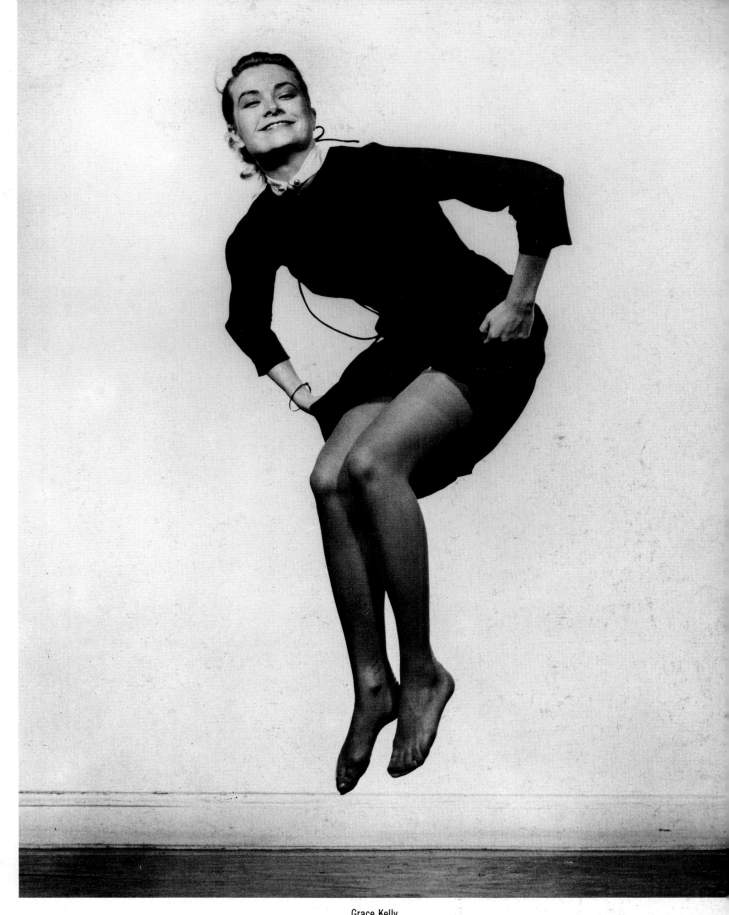

Grace Kelly
The actress who became a princess

Judge Learned Hand
Born 1872, America's most respected jurist

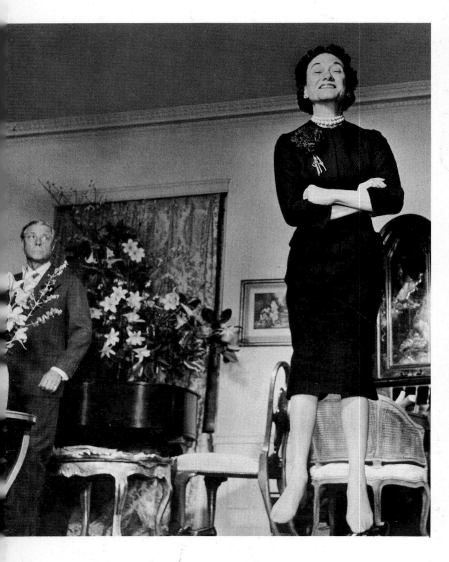

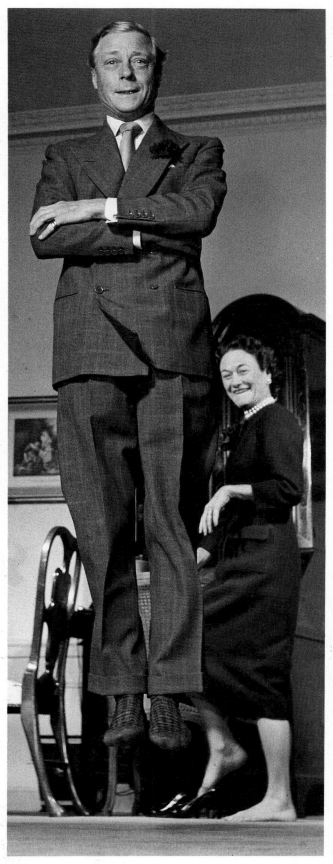

The Duke and
Duchess of
Windsor

The expressions of the Duke
and Duchess watching each other
jump were so revealing and touch-
ing that the author included them
in the picture.

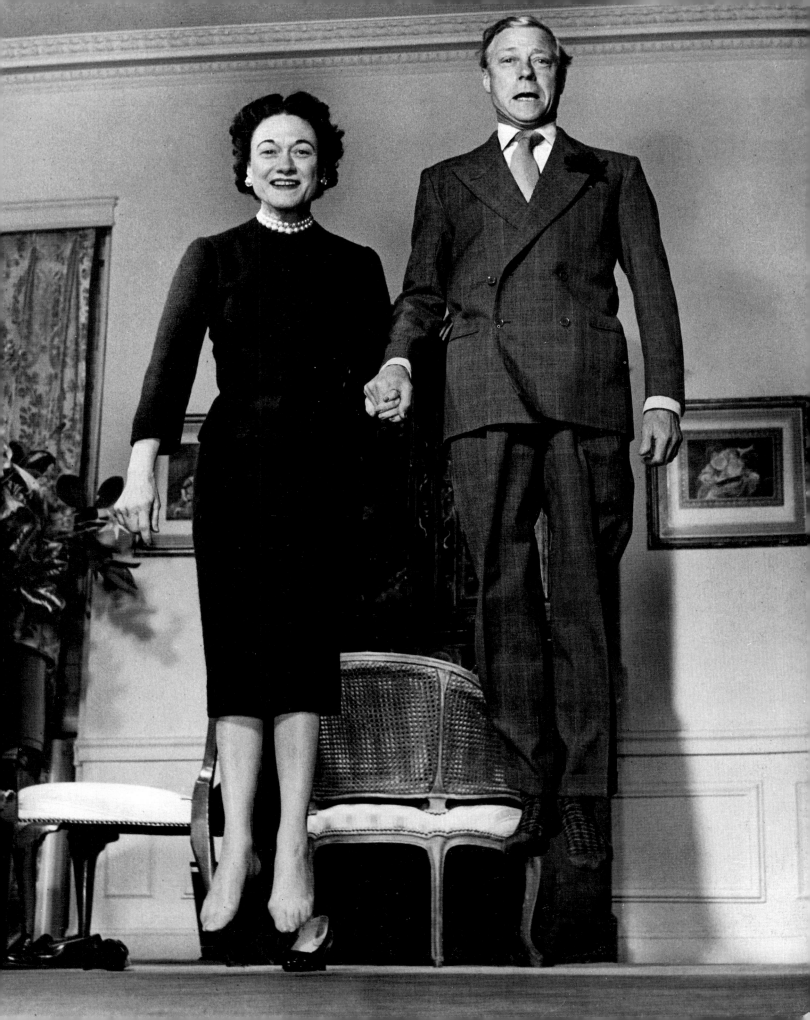

This unusual woman has been editor, playwright, congresswoman and ambassador. When I asked her why she put her hands behind her head during the jump, Mrs. Luce replied, "How can one jump otherwise?" But of the several hundred jumpers I have photographed, she was the only one to take this position.

Clare Boothe Luce

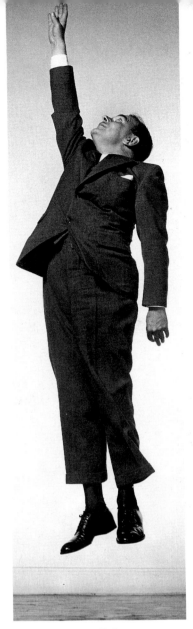

Thomas E. Dewey

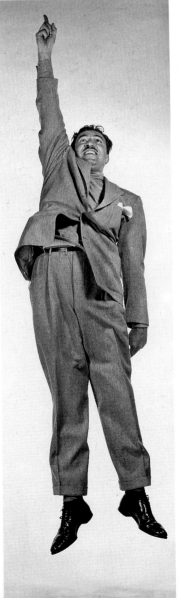

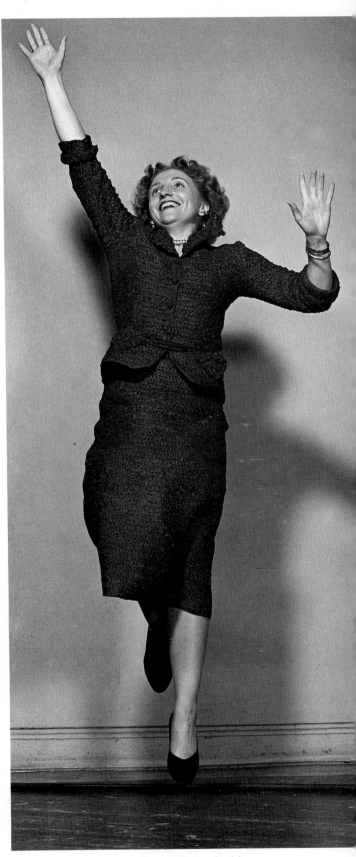

Margaret Truman Daniel

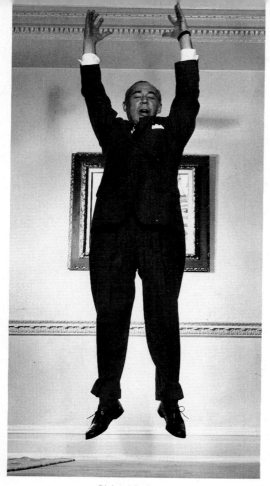

Richard Rodgers

M. Lincoln Schuster

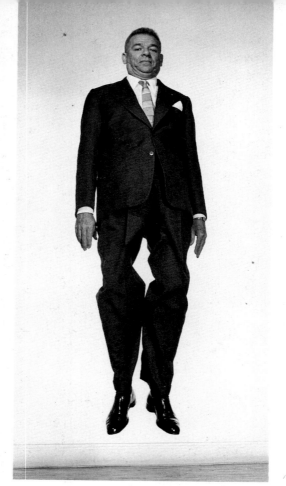

Oscar Hammerstein II

Richard L. Simon

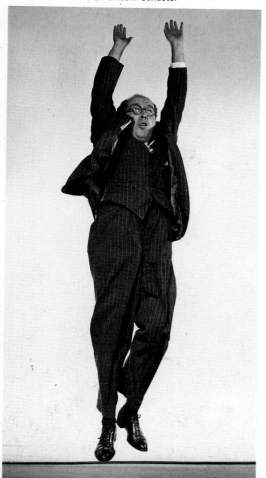

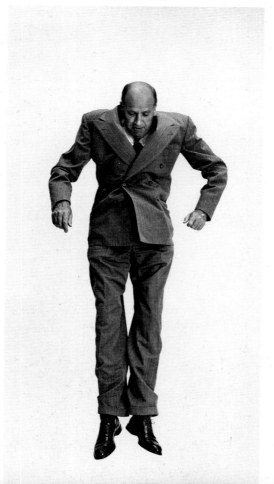

Partners

Each of the four men on the left jumps in a way which is diametrically opposed to the jump of his partner. Their partnerships were lasting and astonishingly successful. The two partners on the right, whose jumps are almost identical, broke up after a few years.

Dean Martin and Jerry Lewis

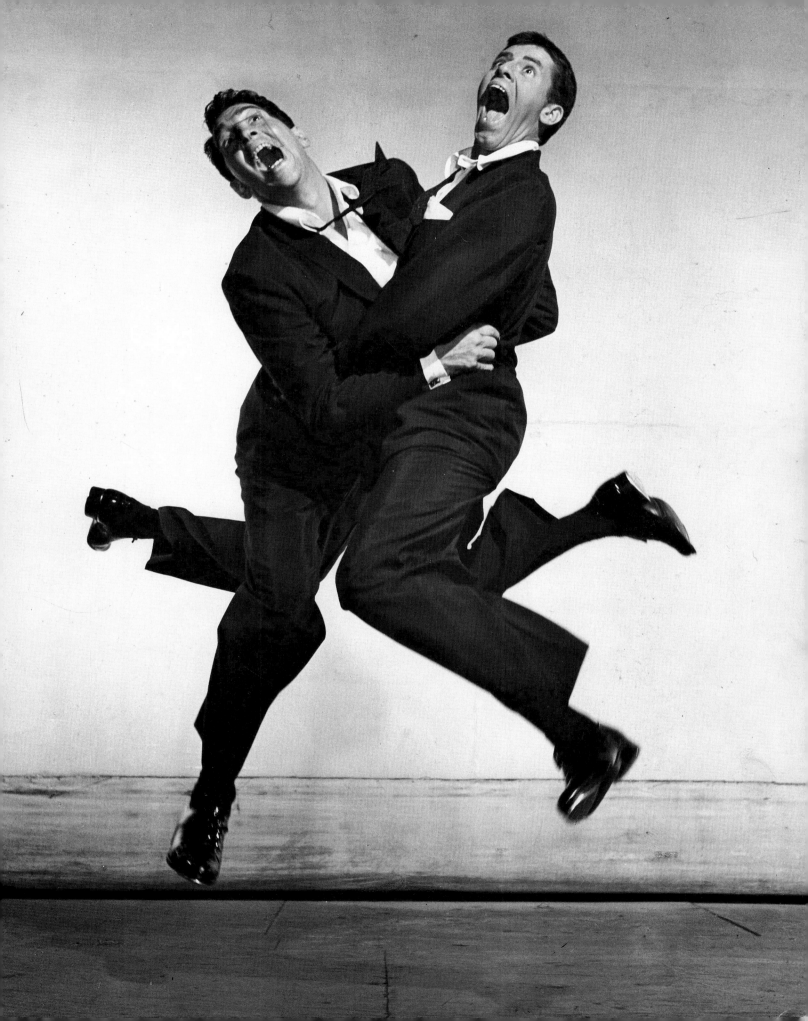

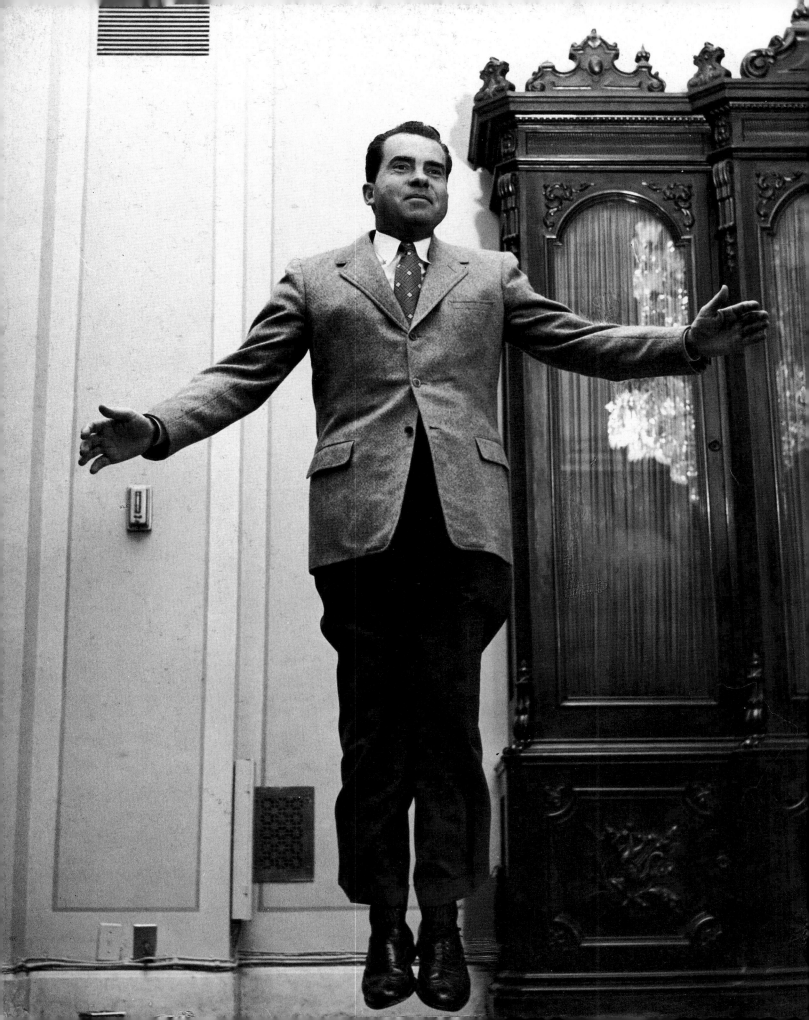

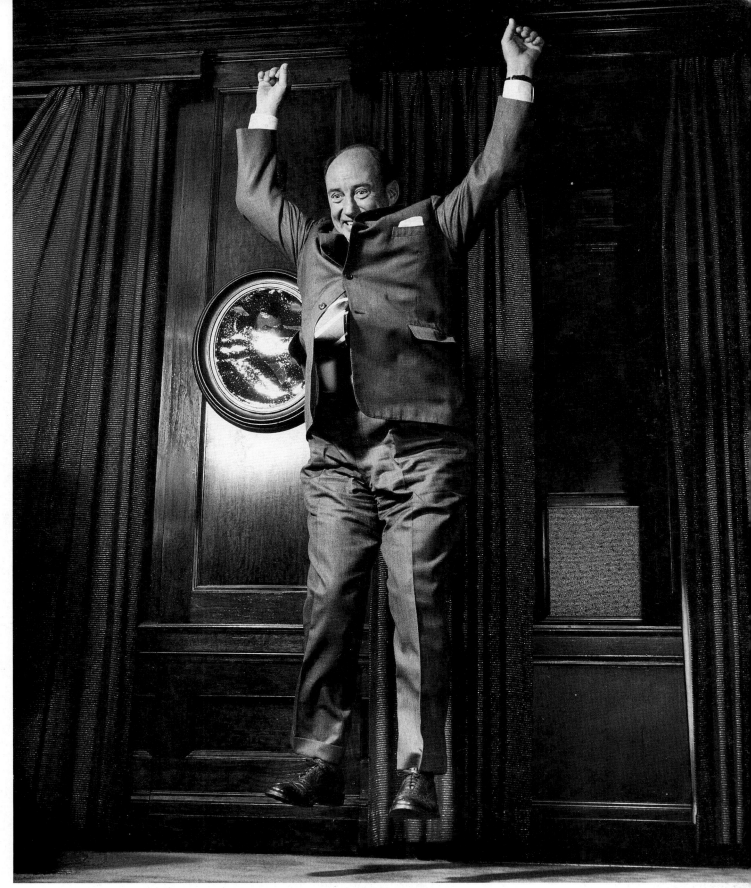

Adlai E. Stevenson

Richard M. Nixon

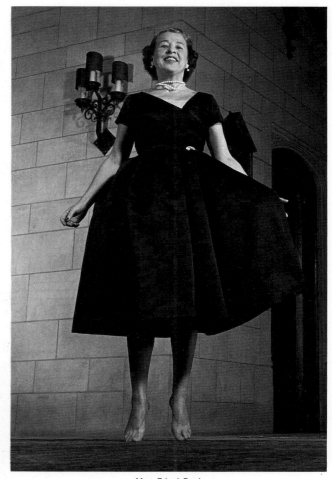

Mrs. Edsel Ford

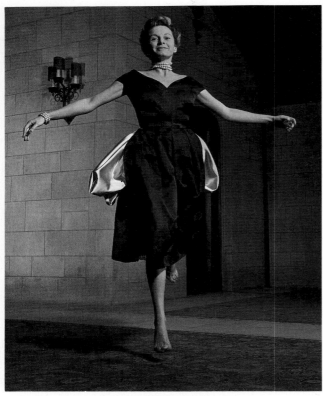

Mrs. Henry Ford II

Two Great Industrial Names

The grace of these three prominent jumpers is the more remarkable since two of them are grandparents.

Harvey S. Firestone, Jr.

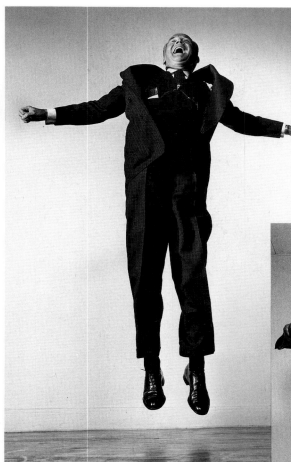

Philip D. Reed
*Chairman of the Board
of General Electric*

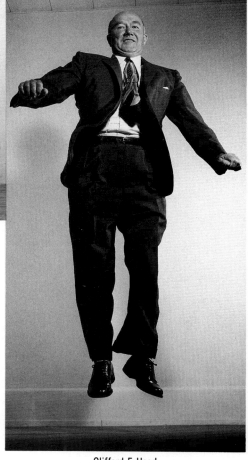

Clifford F. Hood
President of U.S. Steel

Morse G. Dial
Chairman of the Board of Union Carbide

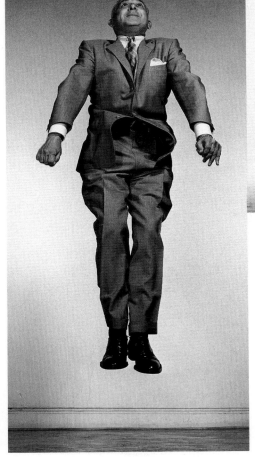

John V. Naish
Executive Vice-President of Convair

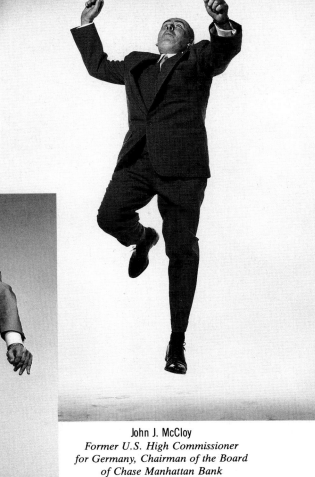

John J. McCloy
*Former U.S. High Commissioner
for Germany, Chairman of the Board
of Chase Manhattan Bank*

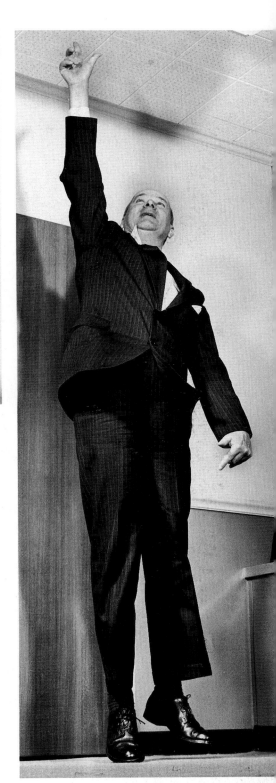

Cyrus R. Smith
President of American Airlines

Captains of Industry and Business

The author apologizes to Mr. Smith for shooting too early and catching the greatest airline president before he was airborne.

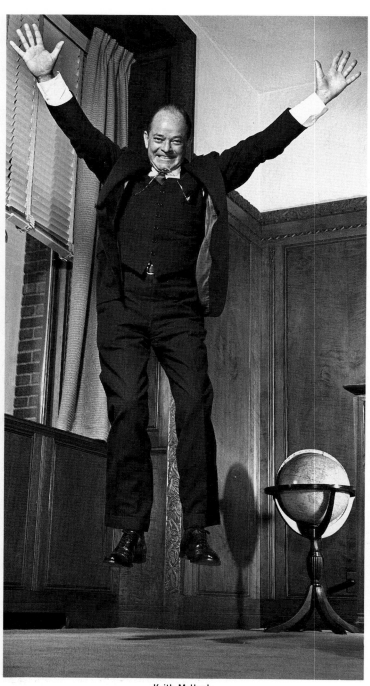

Keith McHugh
President of the New York Telephone Company

Howard S. Bunn
President of Union Carbide

Presidents of Great Corporations

All four men owe their position to their own brilliance and energy. Psychologists will have to decide whether jumping this way predisposes a young man to become president of a great organization.

H.E. Humphreys
President of the U.S. Rubber Company

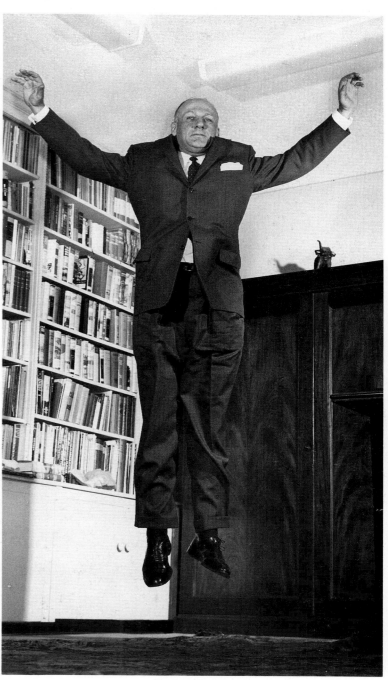

Walter W. Frese
President of Hastings House Publishers

What Have They In Common?

Max Lerner is an author and columnist for the New York *Post*. Walter Kerr is a playwright and the theater critic for the New York *Herald Tribune*. Mike Wallace is a TV interviewer and news commentator. Their similarity does not stop at their identical jump position: all three men are noted for their critical and analytical minds.

PUBLISHER'S NOTE: The three gentlemen also share the same book publisher.

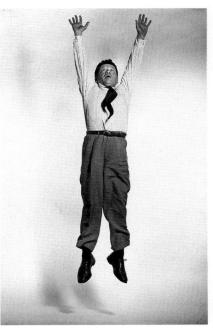

Max Lerner

Are Jumps Hereditary?

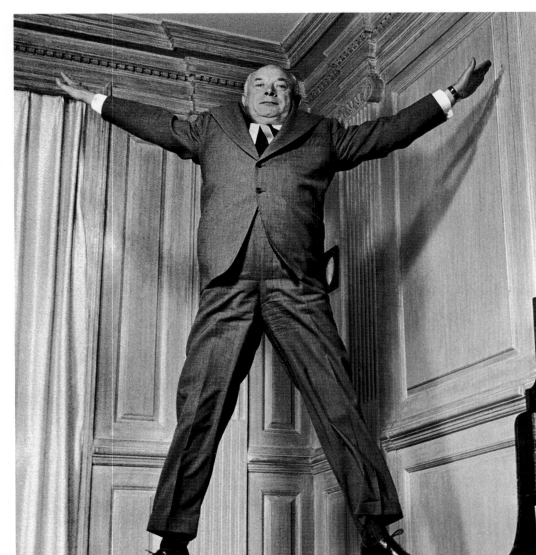

General David Sarnoff
Chairman of RCA

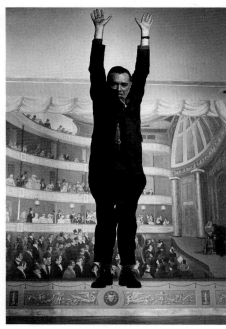

Walter Kerr

Mike Wallace

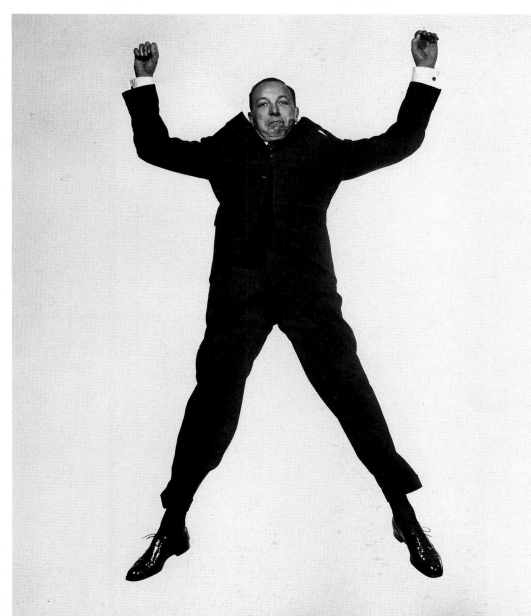

General David Sarnoff jumped for me in November 1954. Fourteen months later I photographed the jump of his son, Robert. When I compared the two jumps I was struck by their similarity.

Since character traits are inherited and jumps reflect character, it is only logical that jumps can be as hereditary as a Bourbon nose or a Hapsburg lip.

Robert W. Sarnoff
President of NBC 51

Abe Burrows

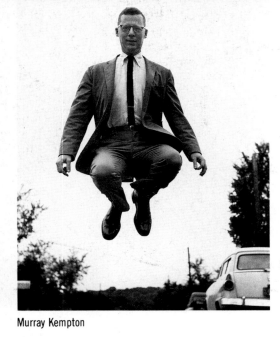

Murray Kempton

Walter Winchell

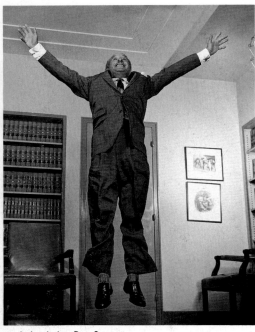

Judge Irving Ben Cooper

H. Rowan Gaither, Jr.

Nahum Goldmann

Bennett Cerf

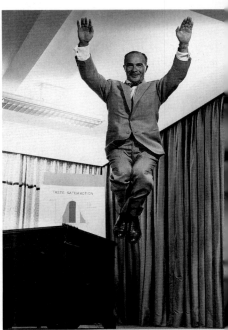

Alfred Politz

James Hag

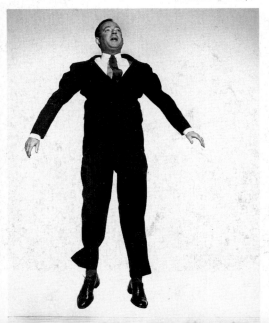

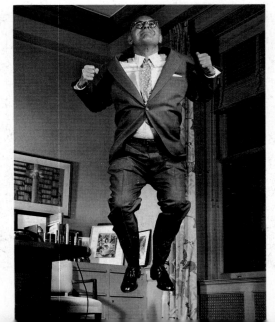

Abe Burrows wrote the book for *Guys and Dolls* and *Can Can*. He is known on Broadway as the Prince of Play Doctors.

Murray Kempton is a newspaper columnist.

Walter Winchell is too well known to need identification.

Chief Justice Irving Ben Cooper is the progressive campaigner for better treatment of youthful first offenders.

Dr. Nahum Goldmann is the president of the World Jewish Congress.

Dr. Alfred Politz is a scientist and the head of his own motivation research organization.

H. R. Gaither, chairman of the Ford Foundation, is the author of the famous Gaither Report.

Bennett Cerf, whose jump shows his irrepressible energy, is author, columnist, TV personality and president of Random House.

James Hagerty is, of course, Ike's press secretary.

Dr. Selman Waksman, born in 1888, is the discoverer of Streptomycin and received the Nobel Prize for Physiology and Medicine in 1952.

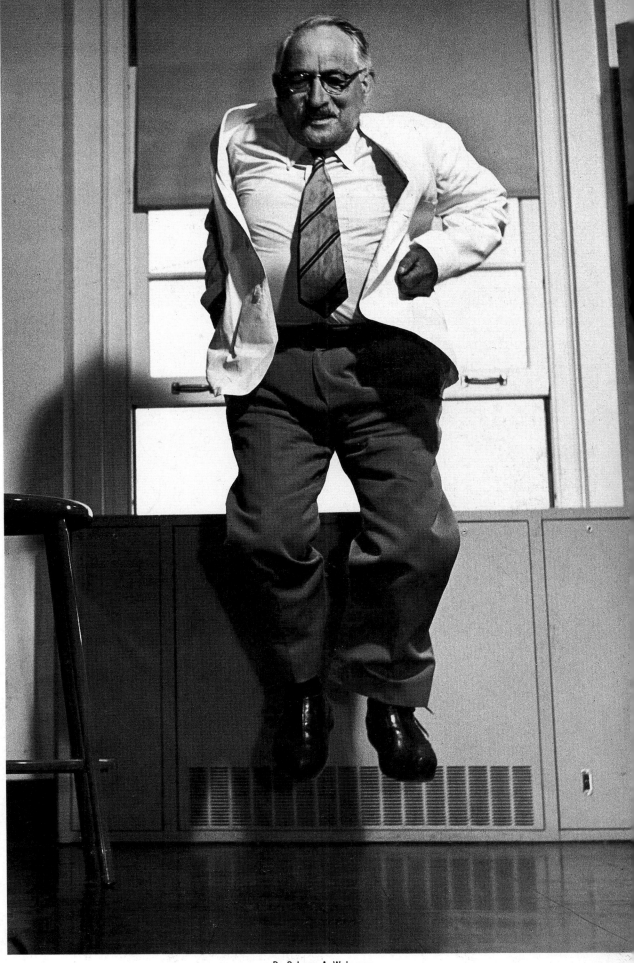

Dr. Selman A. Waksman

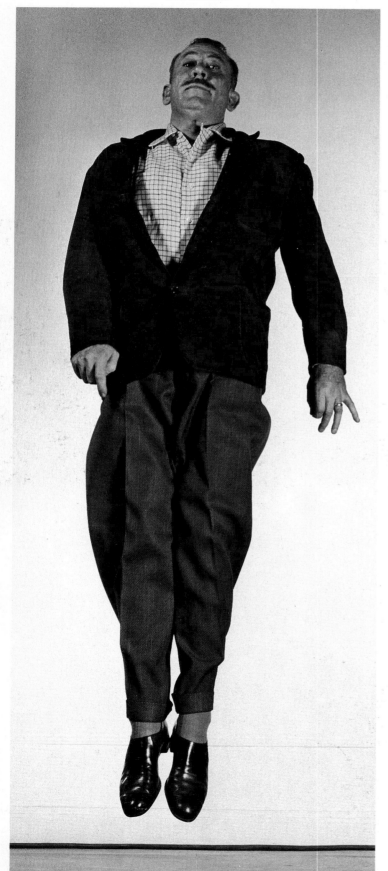

John Steinbeck

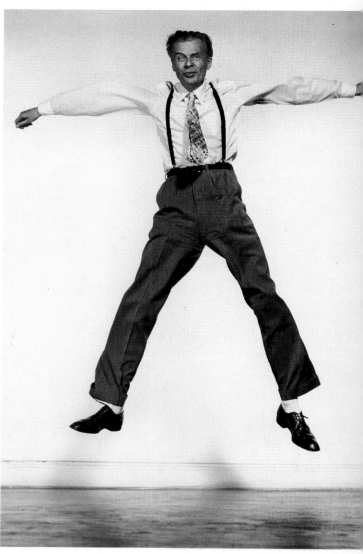

Aldous Huxley

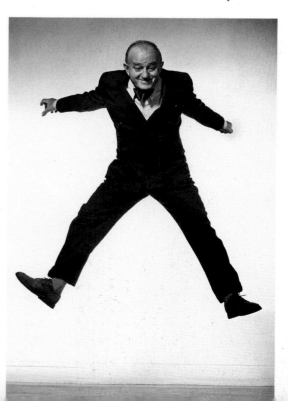

Ben Hecht

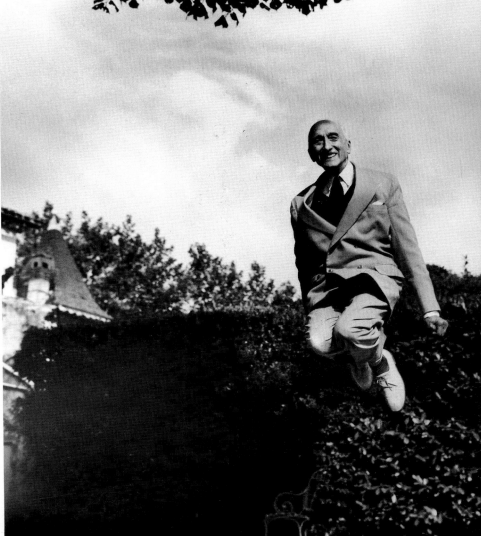

Marcia Davenport

Randall Jarrell

François Mauriac

Shepherd Mead

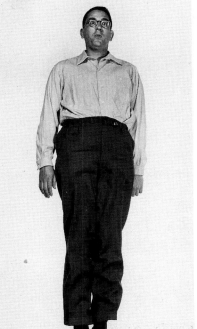

Seven Authors

It is fitting that only the poet and the Frenchman among these writers—Poetry Consultant to the Library of Congress, Randall Jarrell and Nobel Prize-winning novelist François Mauriac—should seem to float against the background of trees and sky. Observing her husband's jump, Mme. Mauriac said admiringly, *"Comme vous sautez bien."* ("How well you jump.")

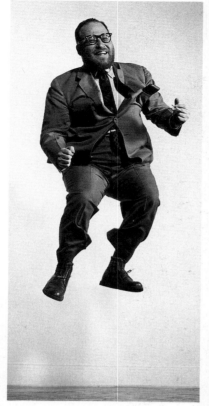

Professor Stanley Hyman

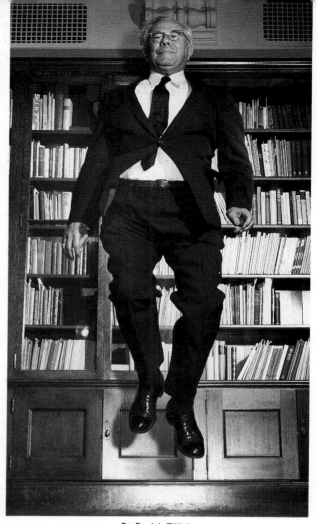

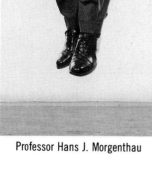

Professor Hans J. Morgenthau

Dr. Paul J. Tillich
Rev. Father Martin Cyril D'Arcy

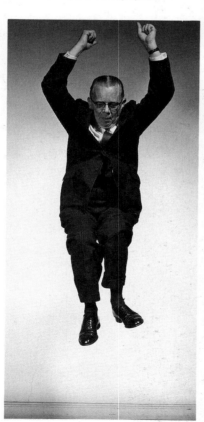

Dr. J. F. W. Pearson

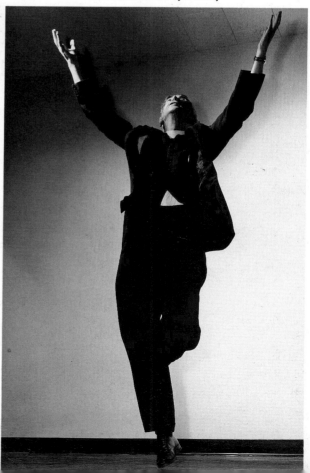

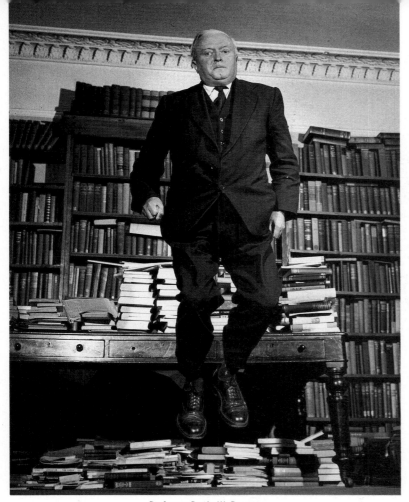

Professor Denis W. Brogan
Professor Loren Eiseley

Scientists and Theologians

In contrast to the straightforward and logical jump of the leading Protestant theologian, Dr. Tillich, the jump of the Jesuit Father D'Arcy is full of spiritual exaltation. The explosive joy of Professor Hyman of Bennington, the modest simplicity of Dr. Morgenthau of Chicago and the impressive altitude reached by the dynamic president of the University of Miami, biologist Dr. Pearson, bear witness to the diversity of the scientific personality. Professor Brogan of Cambridge University is a great expert on American history and civilization. Professor Eiseley is an anthropologist at the University of Pennsylvania.

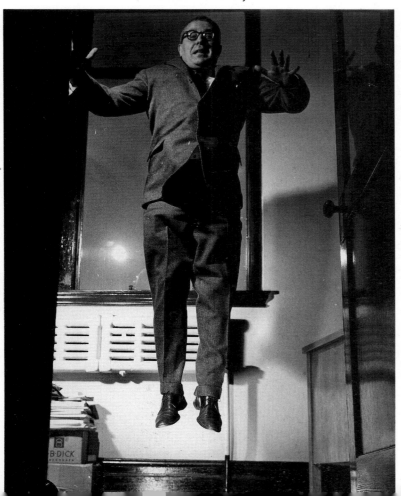

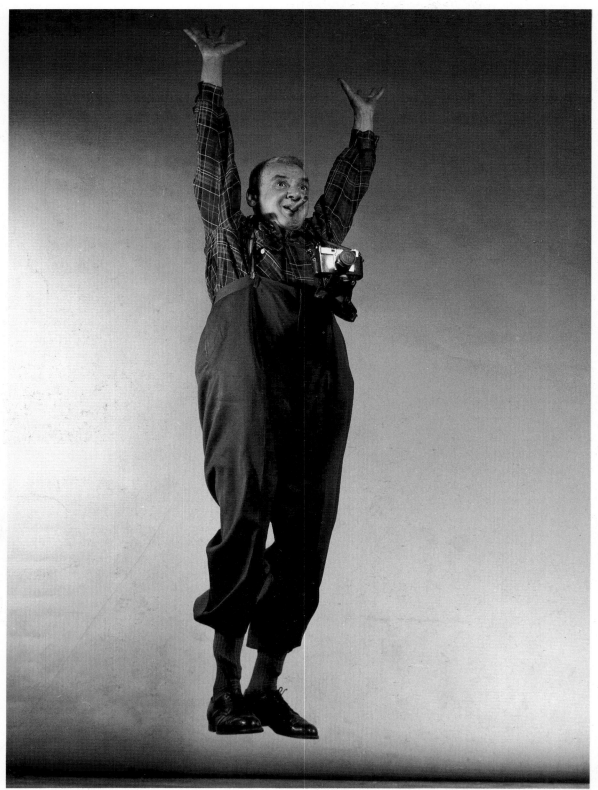

Weegee

Artists and Designers

Weegee is a photographer who roams the city at night, seeking the unusual. The great painter Marc Chagall was photographed in his garden in Vence, France. Walter Gropius is one of the great pioneers of modern architecture. Henry Dreyfuss is one of America's foremost designers.

58

Marc Chagall

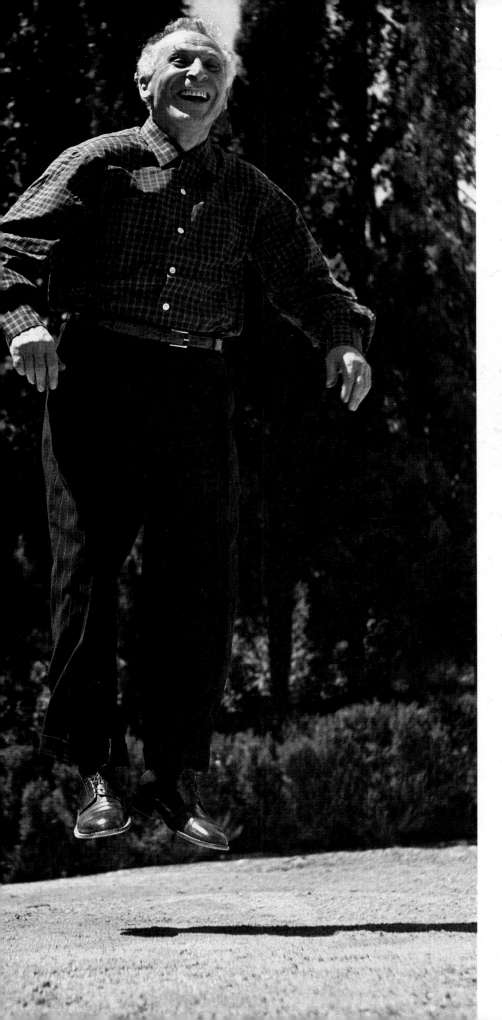

Walter Gropius

Henry Dreyfuss

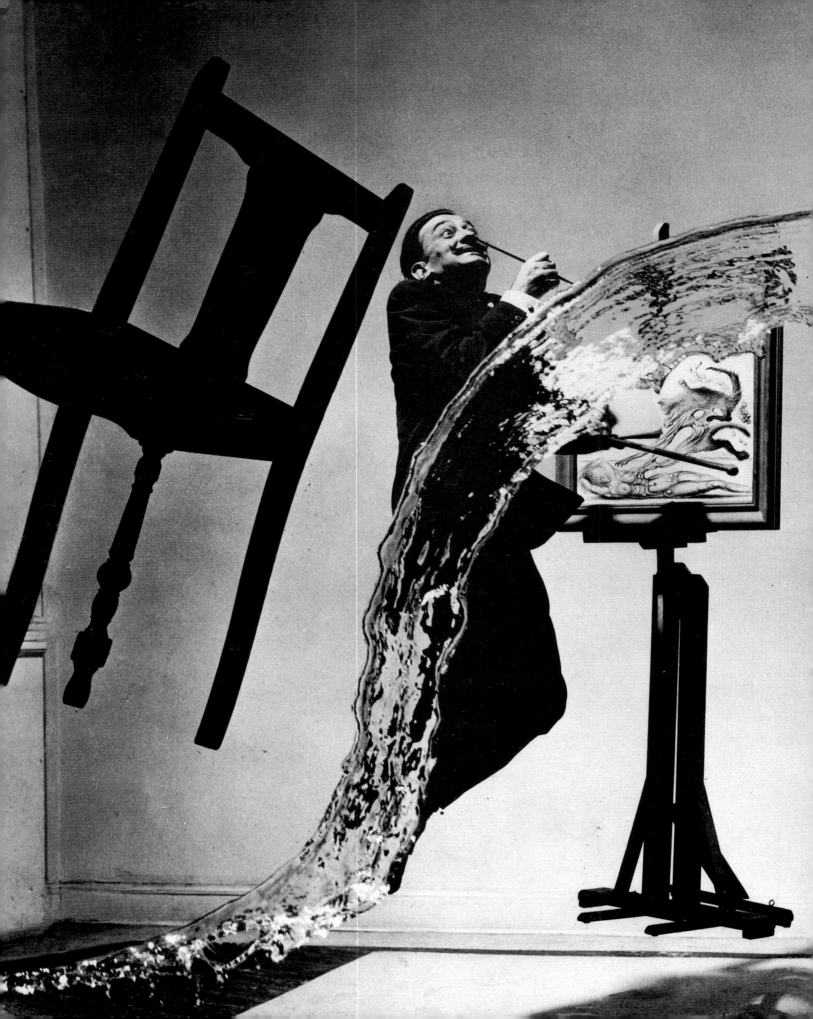

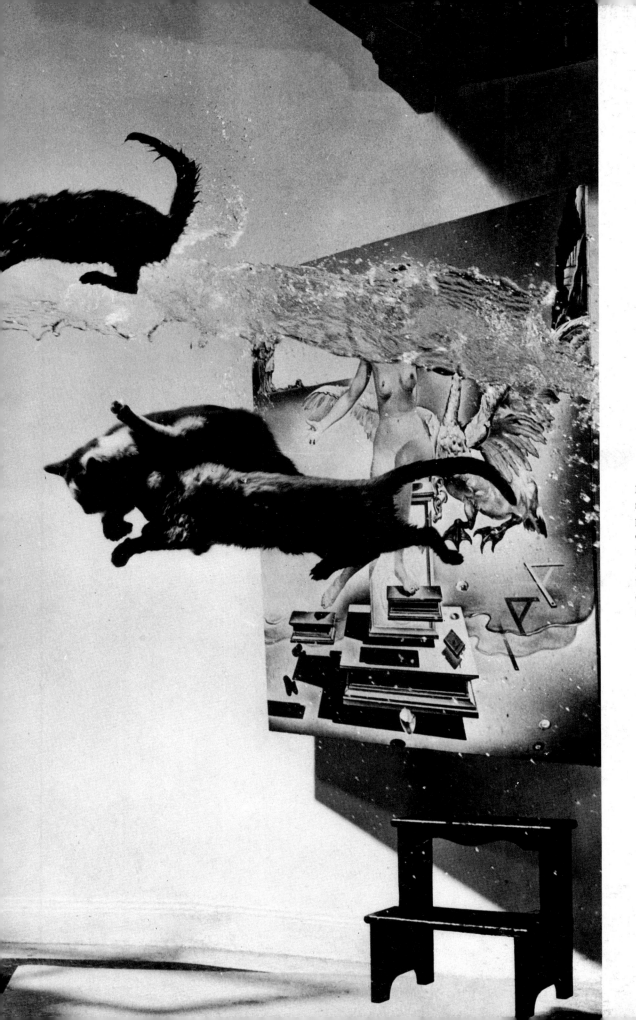

Dali

This portrait of Salvador Dali ("Dali Atomicus") was made during the artist's atomic period, in which he painted everything in suspension. It took 26 triple throws of cats and 26 splashes of water to obtain in the 26th exposure a composition which suited the author's demanding taste.

The World of Entertainment

A great comic dancer and five great comedians jump on these two pages. On the following pages we see in mid-air 18 great names in American television.

Ray Bolger

Danny Kaye

Fernandel

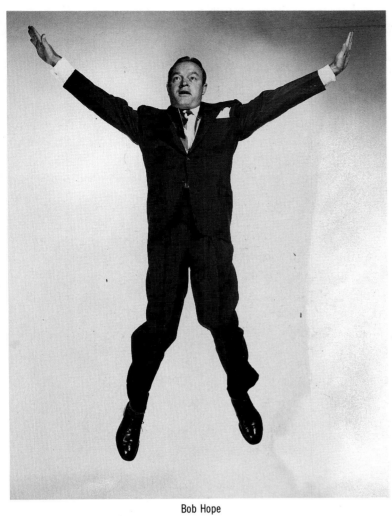

Bob Hope

Jacques Tati

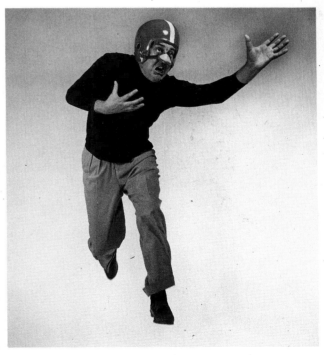

Harold Lloyd

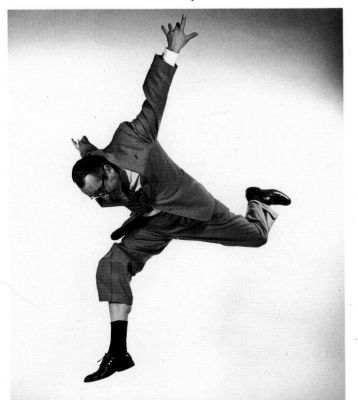

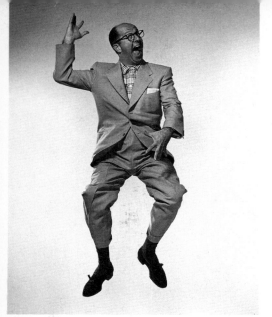

Phil Silvers

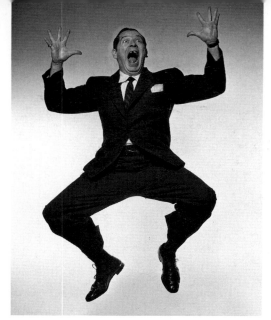

Milton Berle

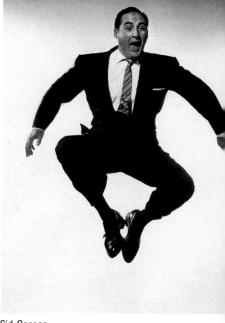

Sid Caesar

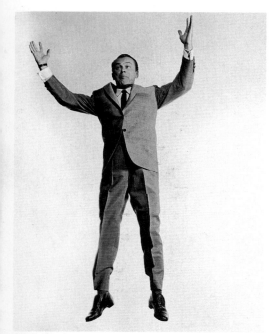

Jack Paar

Garry Moore

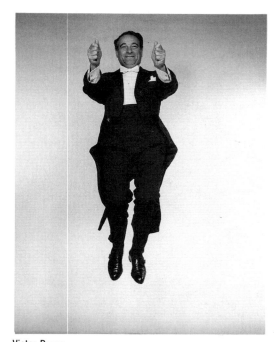

Victor Borge

Jackie Gleason

Danny Thomas

Art Car

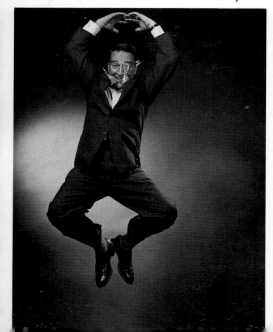

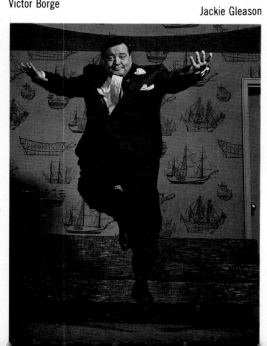

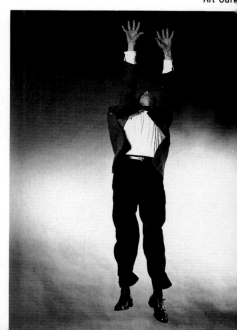

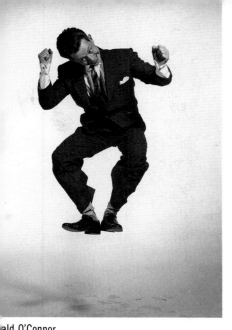

ald O'Connor

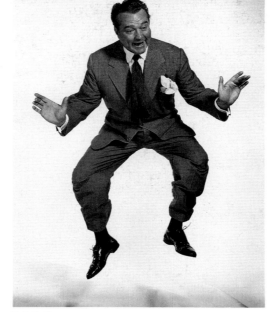

Red Skelton

Dave Garroway

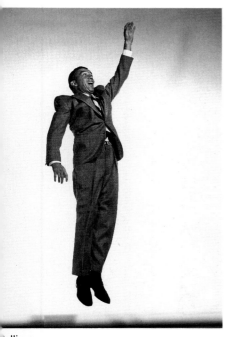

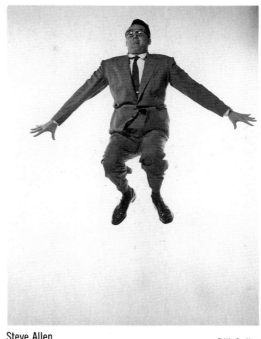

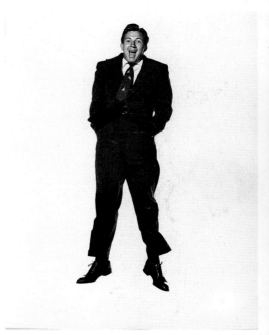

Sullivan

Perry Como

Steve Allen

Bill Cullen

Herb Shriner

Ralph Edwards

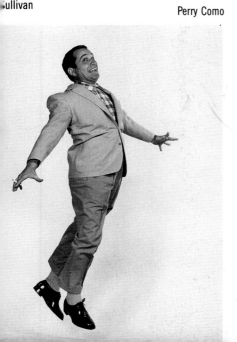

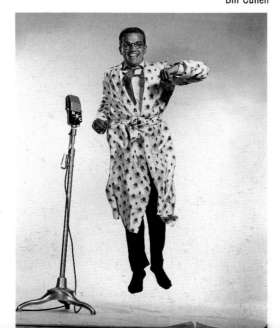

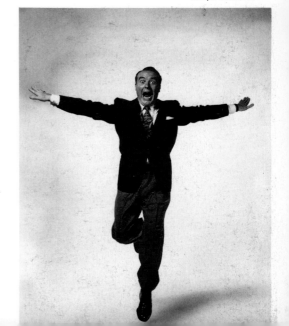

Gisele MacKenzie

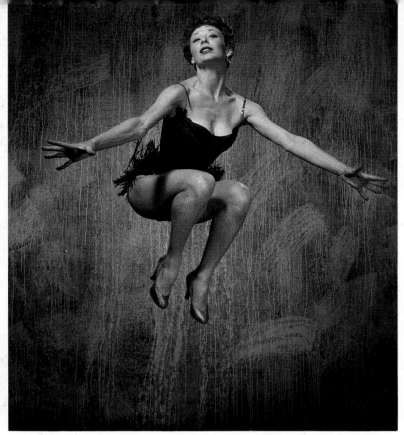

Gwen Verdon

Polly Bergen

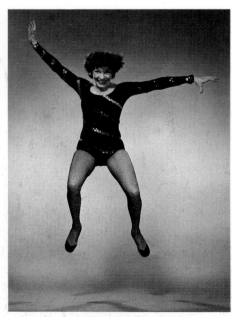

Martha Raye

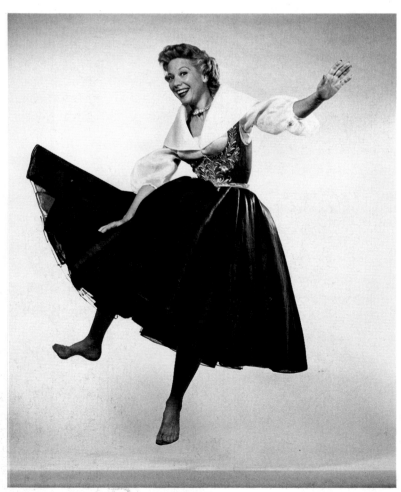

Dinah Shore

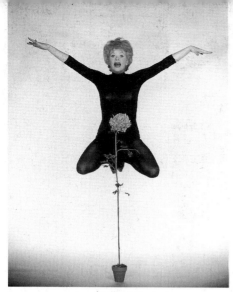

Lucille Ball

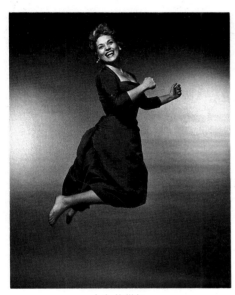

Judy Holliday

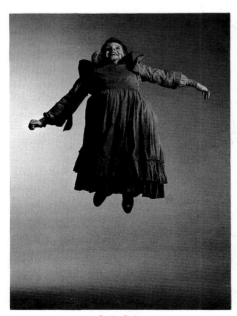

Patty Duke

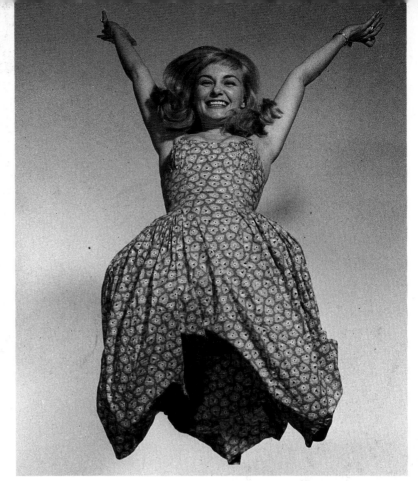

Joanne Woodward

Actresses and Singers

Here the principal means of expression seem to be legs. The comediennes especially use them most creatively, but the neatest trick is performed by Joanne Woodward, whose legs vanish in the flower of her skirt.

Margaret O'Brien

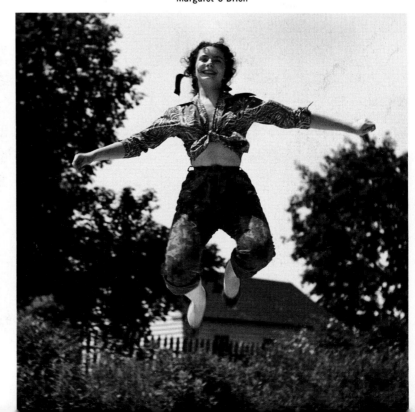

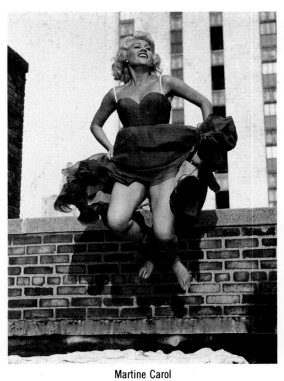

Martine Carol

Nancy Berg

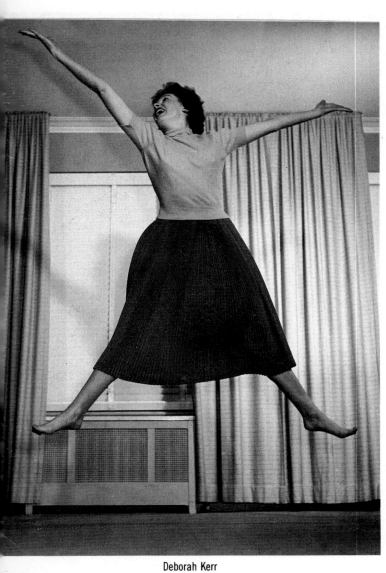

Deborah Kerr

The Eloquence of Legs

Sophia Loren

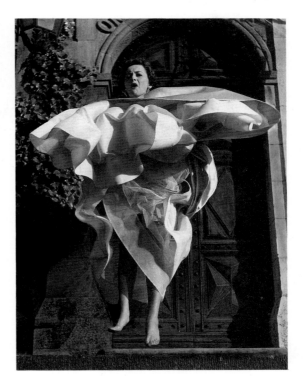

Olivia de Havilland

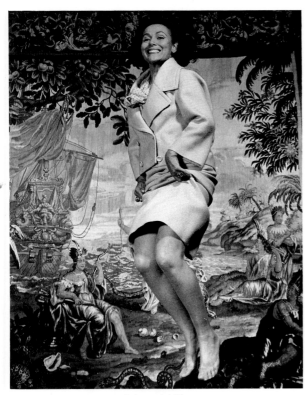

Dolores del Rio

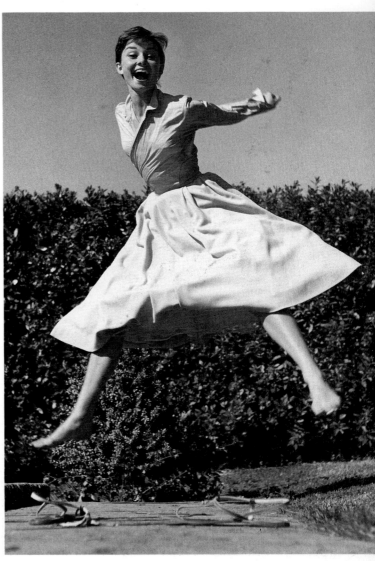

Audrey Hepburn

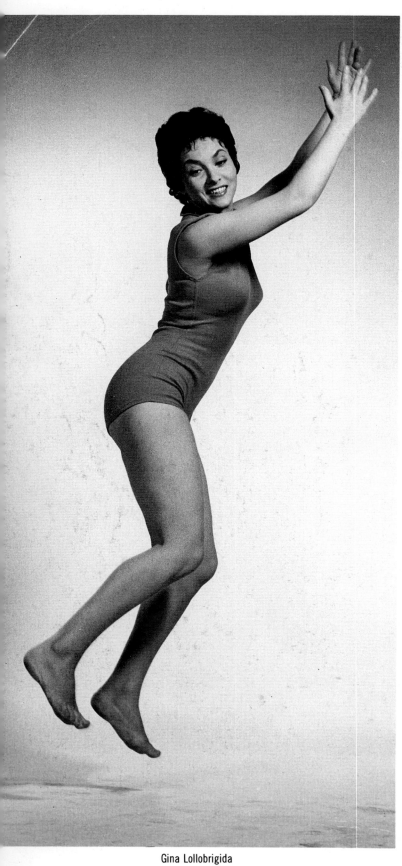

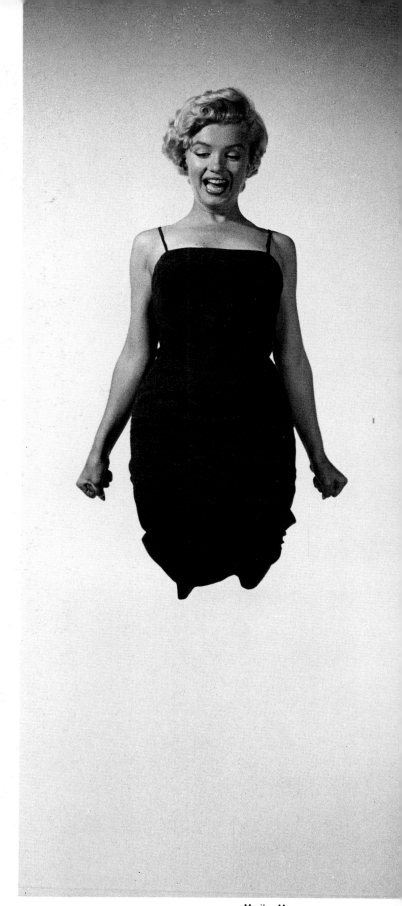

Gina Lollobrigida

Marilyn Monroe

Brigitte Bardot

The Love Goddesses

The childlike playfulness of their jumps shows that
the image the public has of them is nothing but the reflec-
tion of the public's own desires.

Bobby Clark

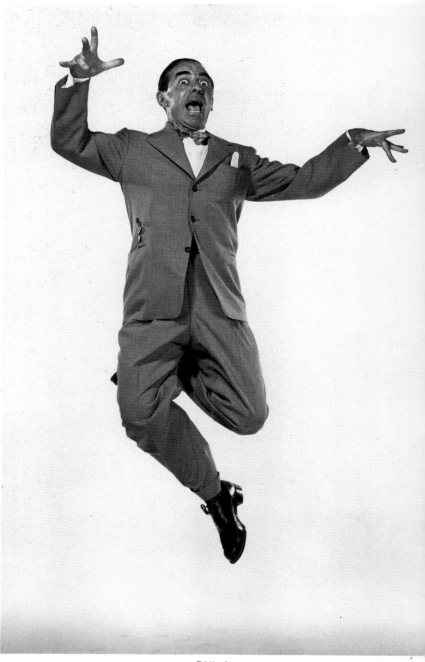

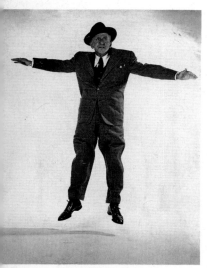

Jimmy Durante

Groucho Marx

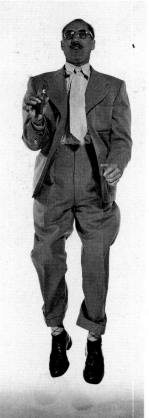

Eddie Cantor

Veteran Comedians

Bobby Clark was born in 1888. Chevalier in 1889, Cantor in 1892 and Durante in 1893. The baby of the group is Groucho Marx—a young man of 64.

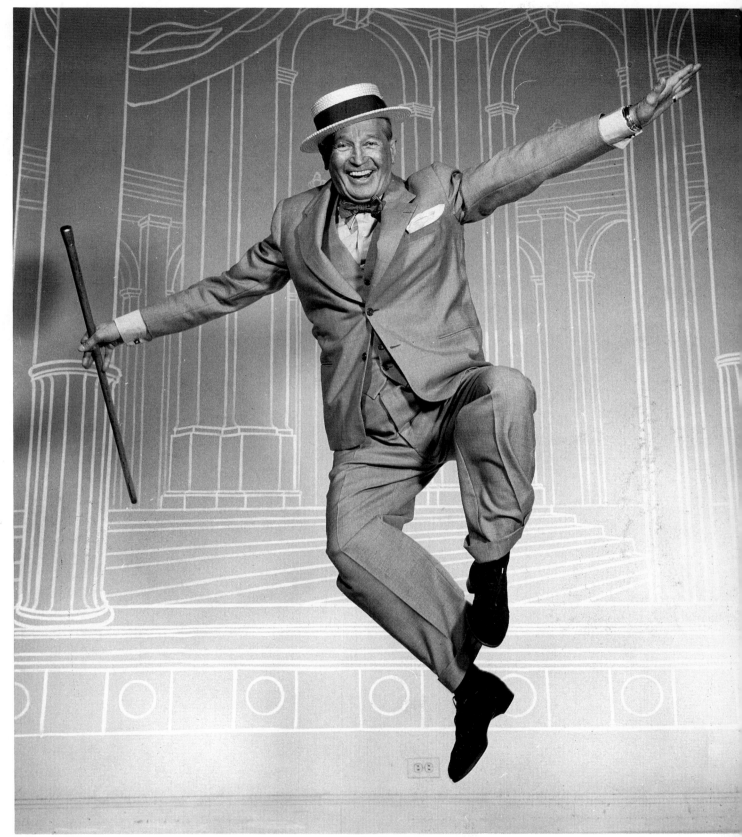

Maurice Chevalier

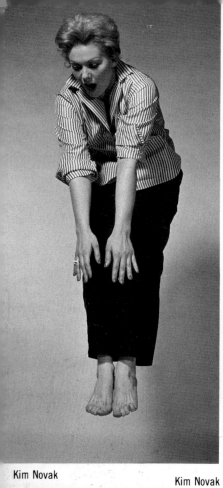

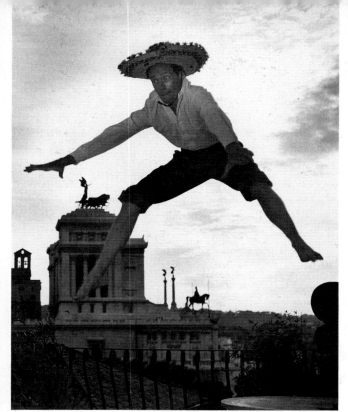

Mel Ferrer

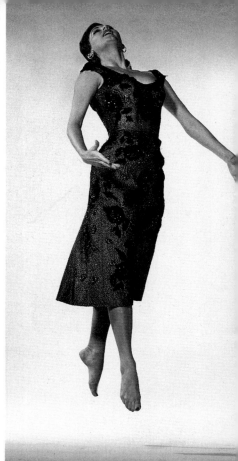

Kim Novak

Kim Novak

Kim Novak made two jumps completely opposite in mood, revealing the ups and downs of her emotional makeup.

Ava Gardner

Dawn Addam

Shirley Temple

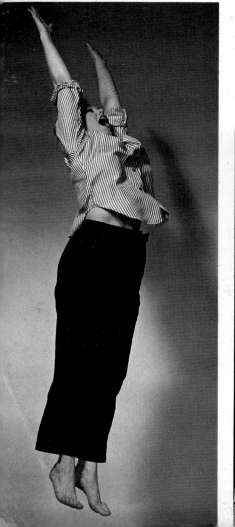

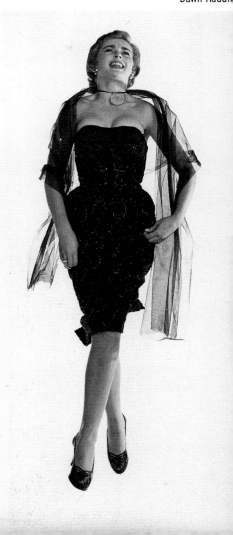

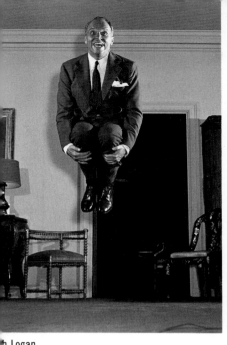

h Logan

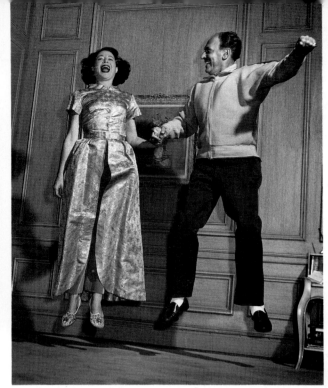

Kitty Carlisle and Moss Hart

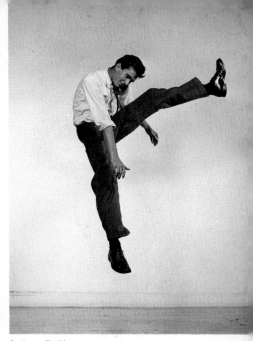

Anthony Perkins

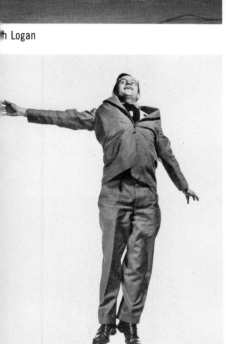

lly Cox

Charles Boyer

Steve Lawrence and Eydie Gormé

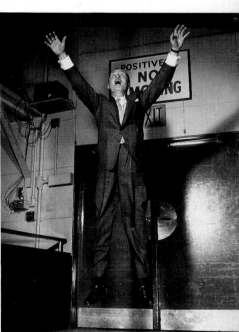

Robert Montgomery

Tab Hunter

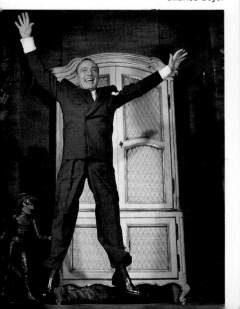

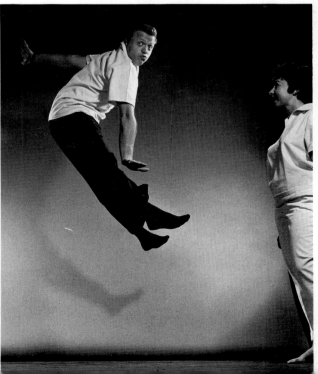

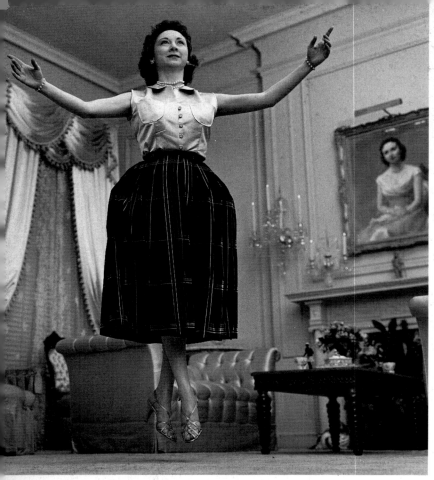

Dorothy Kilgallen

Dany Robin

Glynis Johns

Siobhan McKer

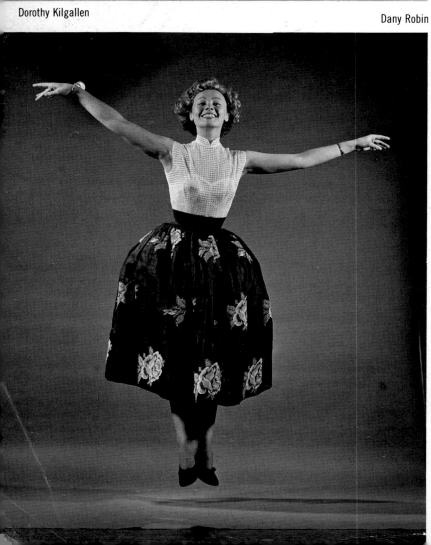

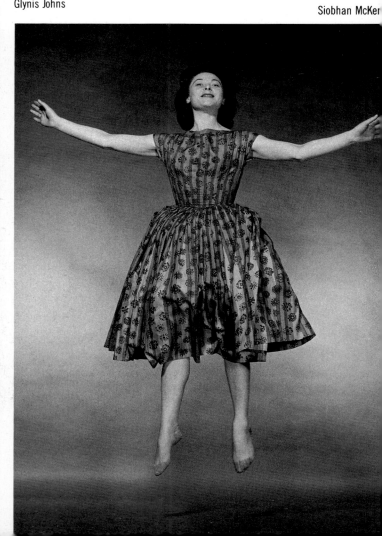

An International Ballet and a Russian Englishman

Dorothy Kilgallen is the American columnist and TV personality. Glynis Johns is an English movie star. Dany Robin is a French *vedette du cinéma*, and Siobhan McKenna is the great Irish actress. The British actor and playwright Peter Ustinov (here without beard) is so cerebral that he can't stop reading even during a jump.

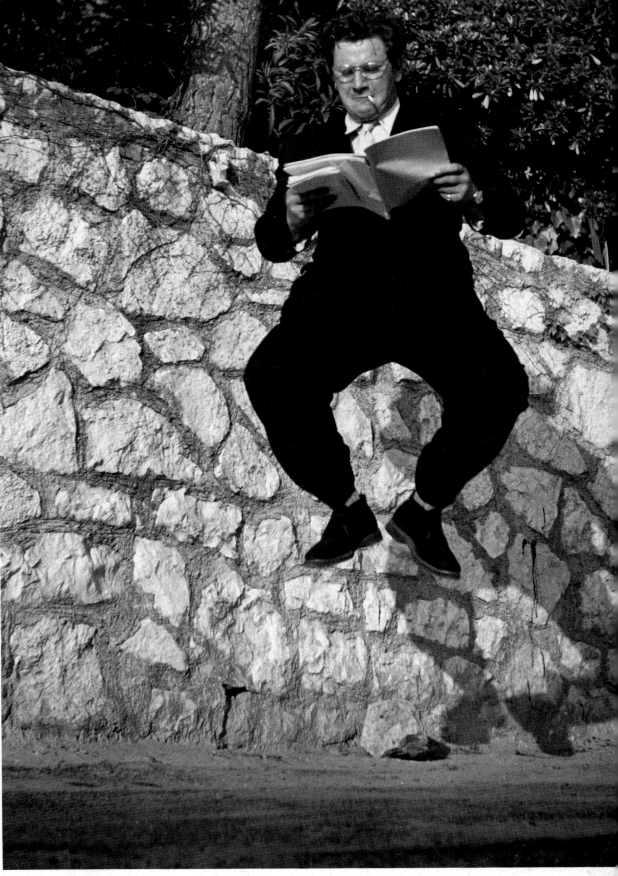

Peter Ustinov

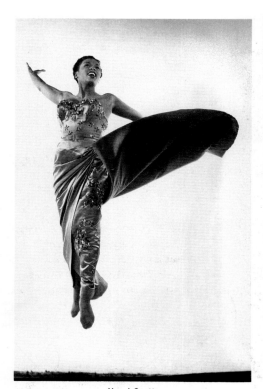

Hazel Scott

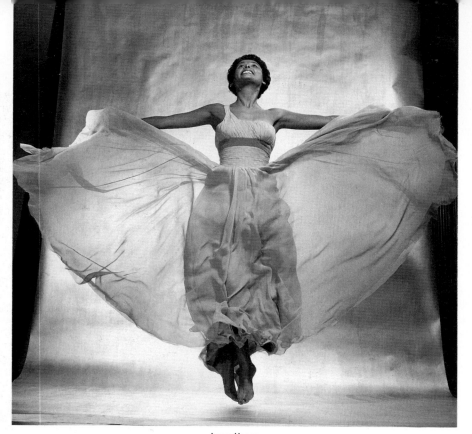

Lena Horne

Arlene Dahl

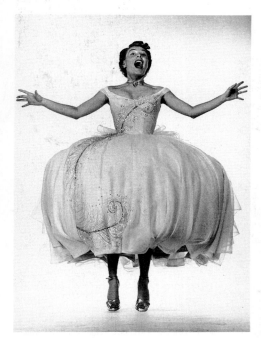

Mindy Carson

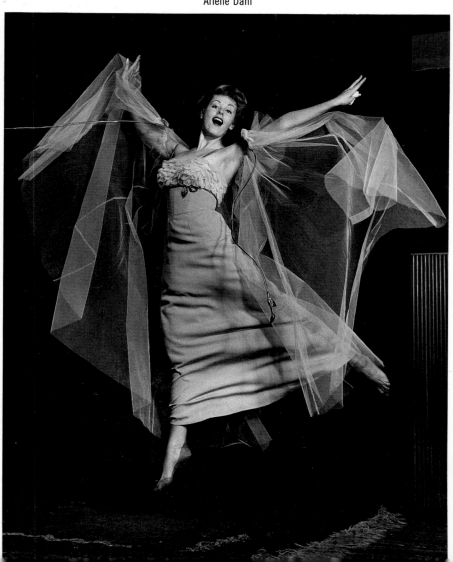

78

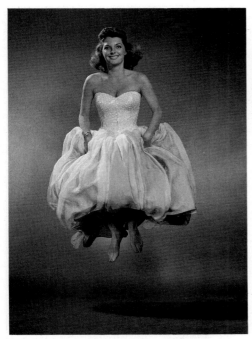

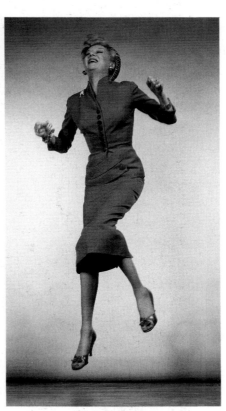

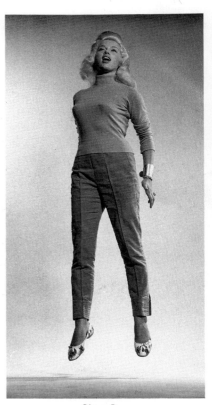

American Flamboyance and British Reserve

Although the author is congenitally weary of generalizations, he is inclined to find the difference between these three British and six American jumps rather characteristic.

Eartha Kitt

Pamela Brown

Julie London

Margaret Leighton

Diana Dors

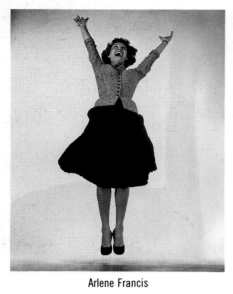

Arlene Francis

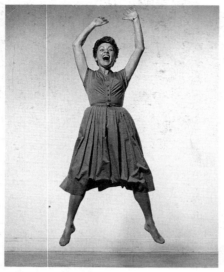

Lillian Roth

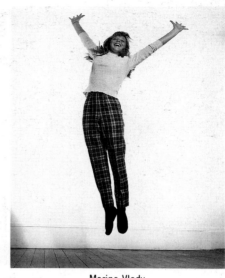

Marina Vlady

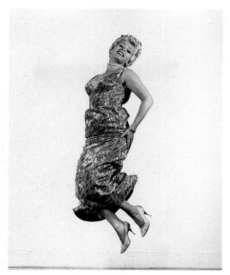

Zsa Zsa Gabor

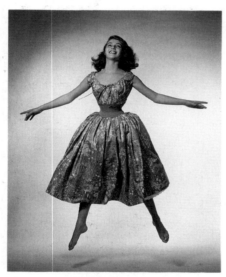

Pier Angeli

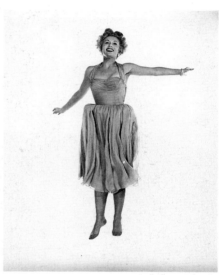

Eva Gabor

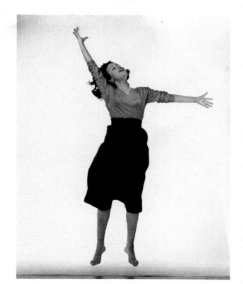

Hilda Simms

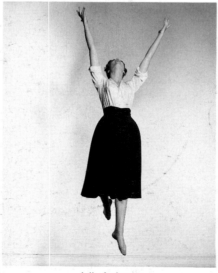

Julie Andrews

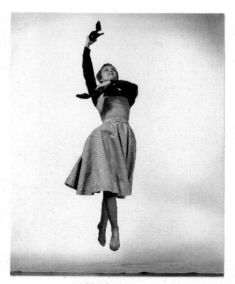

Mai Zetterling

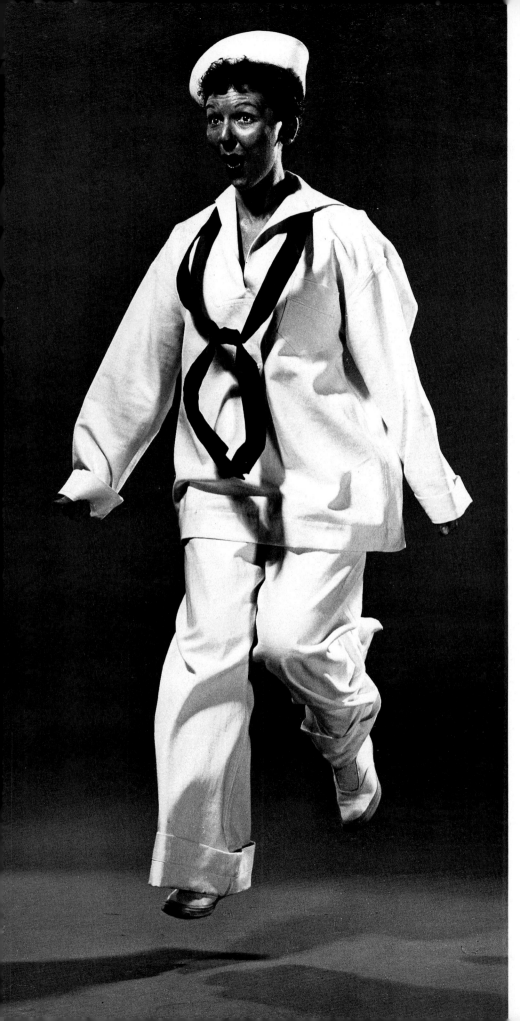

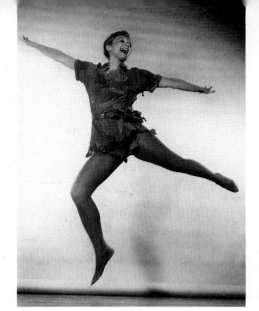

Mary Martin

Actresses and Singers

In fairness to Mary Martin I must point out that her jumps express more the natures of Nellie Forbush and Peter Pan than Mary's own delightful self.

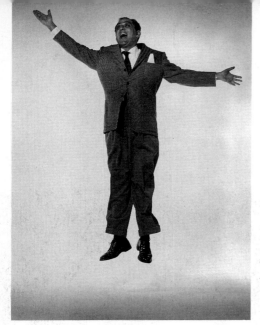

Robert Merrill

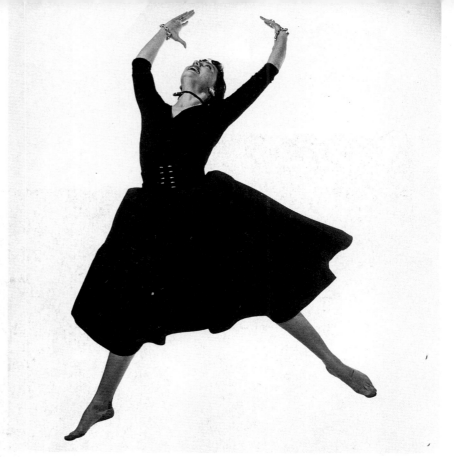

Marguerite Piazza

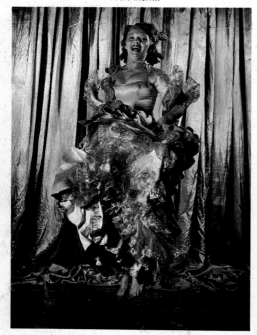

Virginia Haskins

Benny Goodman

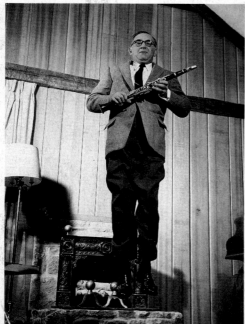

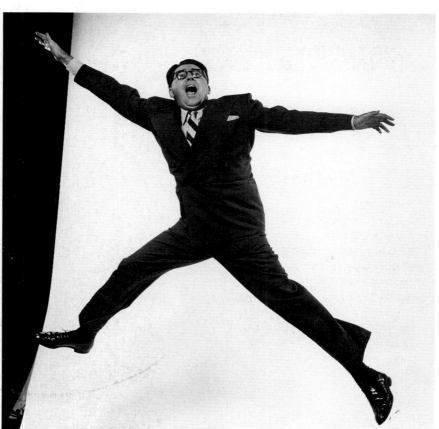

Meredith Willson

Patrice Munsel

World of Music

Robert Merrill is a baritone, Virginia Haskins a soprano, Benny Goodman a jazz musician, Marguerite Piazza a soprano, Meredith Willson the author-composer of *The Music Man*, Patrice Munsel a soprano, and Marian Anderson, a great singer who is also a member of the American delegation to the United Nations.

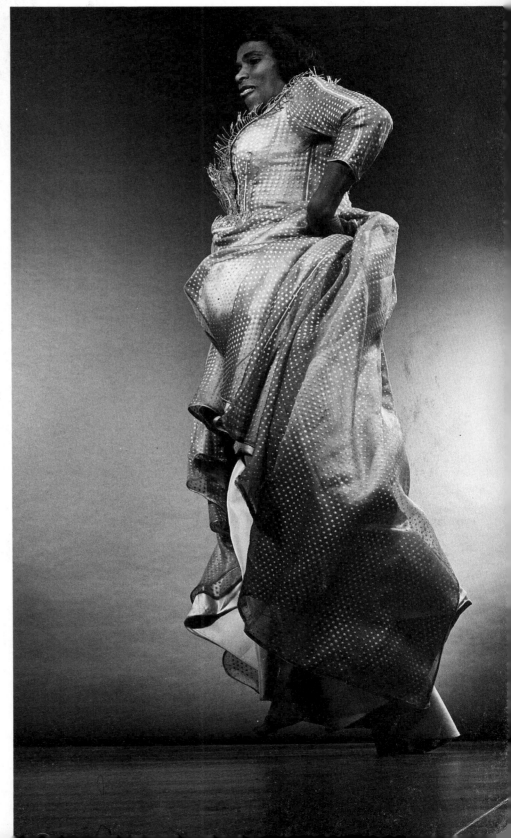

Marian Anderson

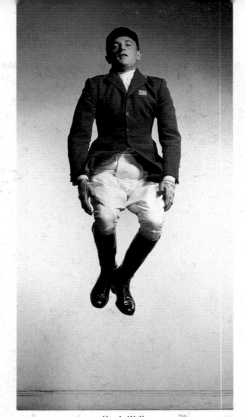

Hugh Wylie

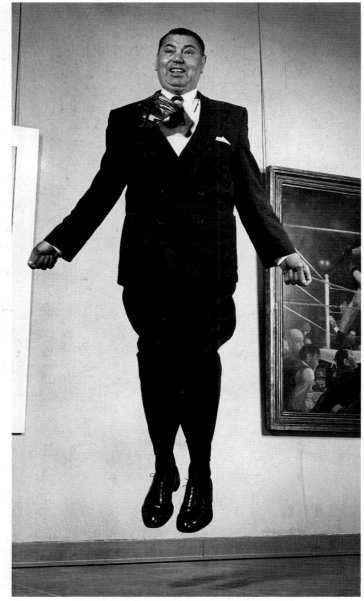

Jack Dempsey

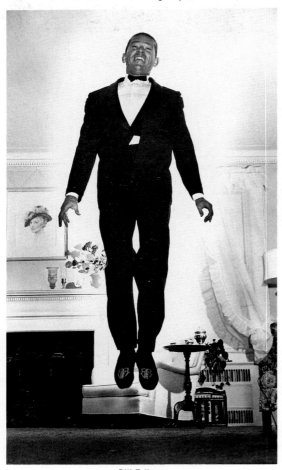

Bill Talbert

Great Athletes

Hugh Wylie is the American champion rider of jumping horses. Bill Talbert is a tennis champion and captain of the American Davis Cup team. Jack Dempsey is the legendary heavyweight champion.

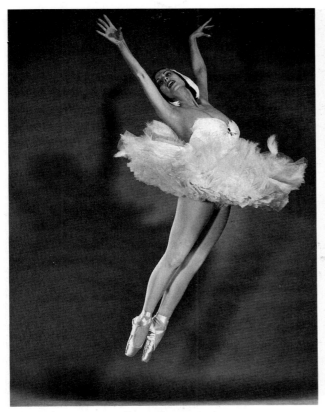

Tamara Toumanova

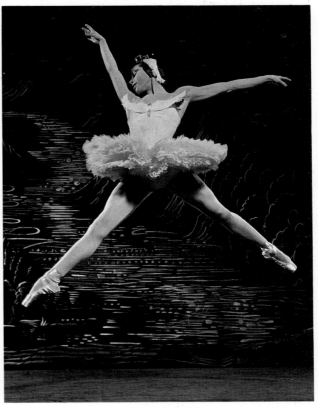

Maria Tallchief

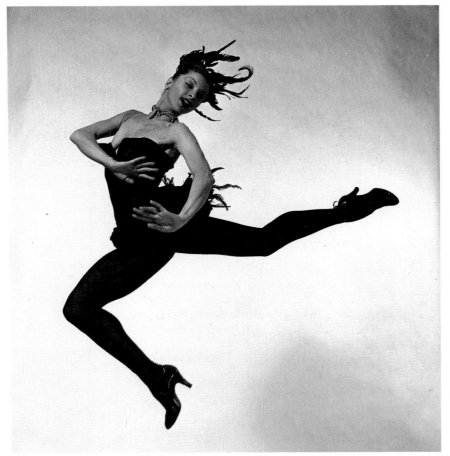

Colette Marchand

Great Ballerinas

The jump of a ballerina is molded by rigid dance tradition. Her only freedom to express herself is the freedom of choice and of mood.

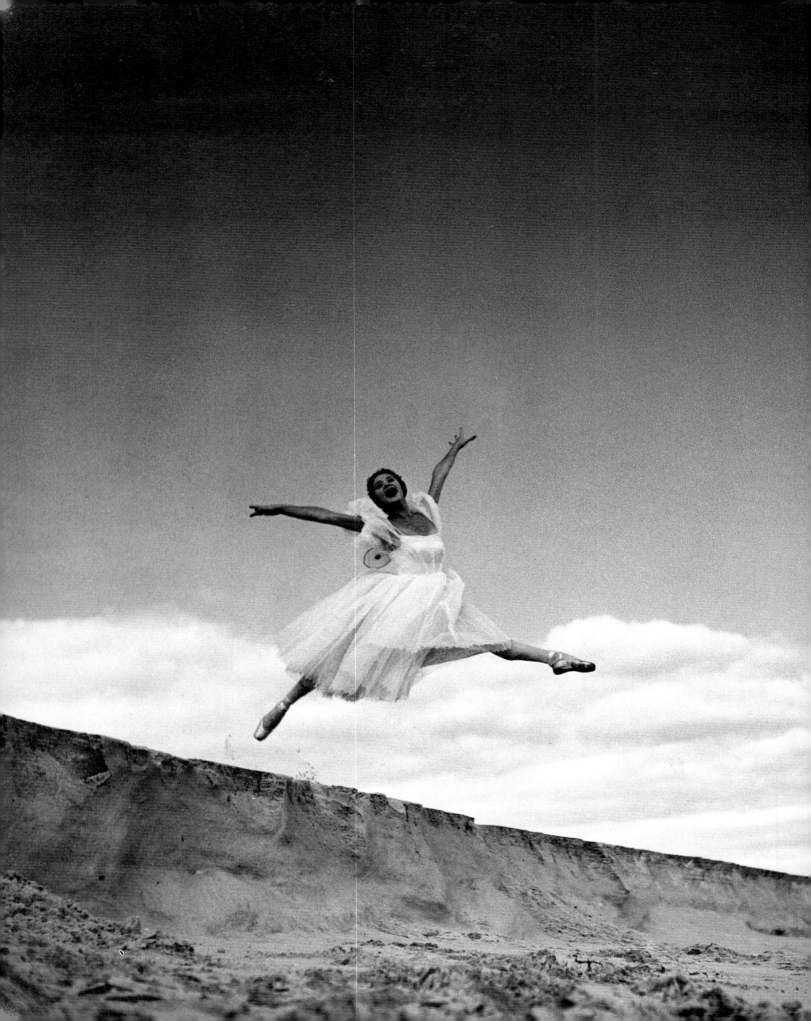

Renée Jeanmaire

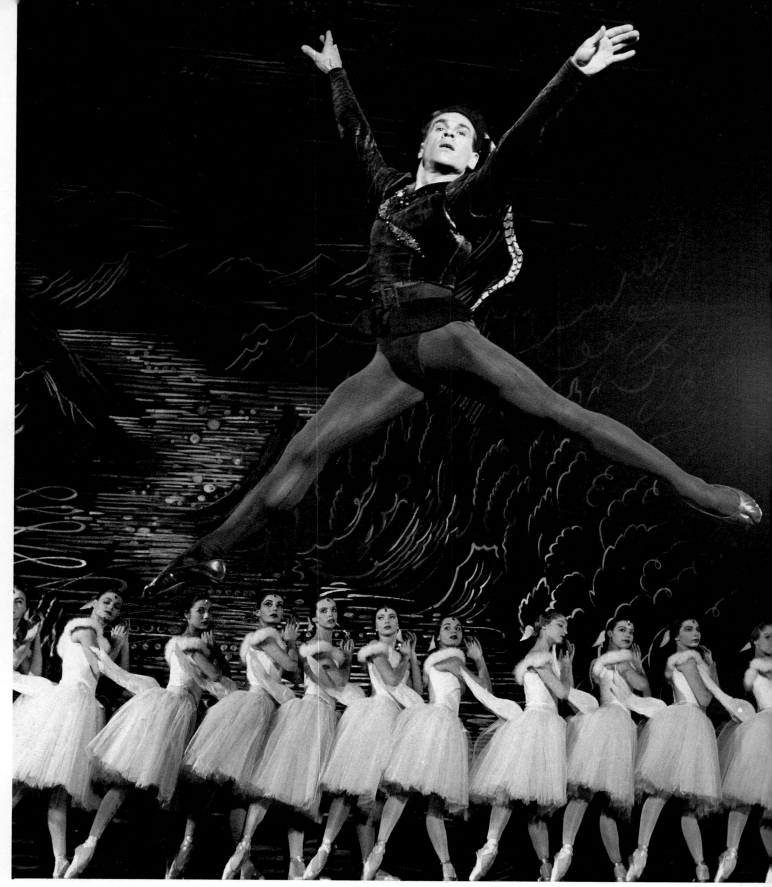

André Eglevsky

Edward Villela

The Cat Girl, Lilly Christine

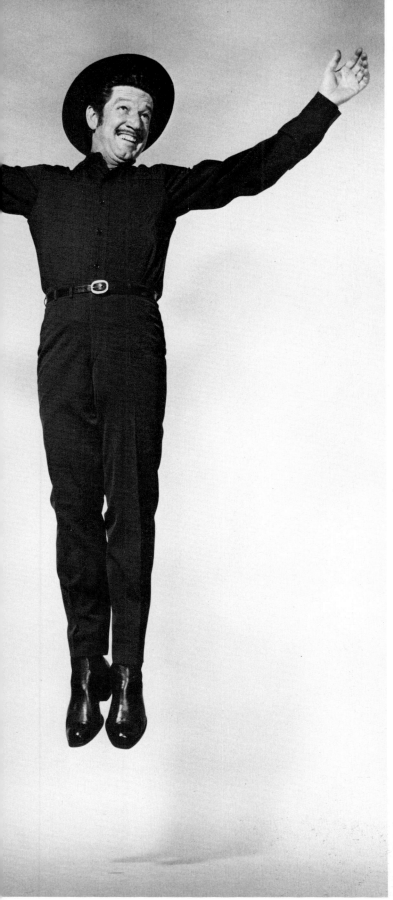

Richard Boone

Male and Females

Paladin's masculine elegance is contrasted with the outstanding feminine charms of Lilly Christine (photographed in her working clothes) and of Jayne Mansfield as Joan of Arc.

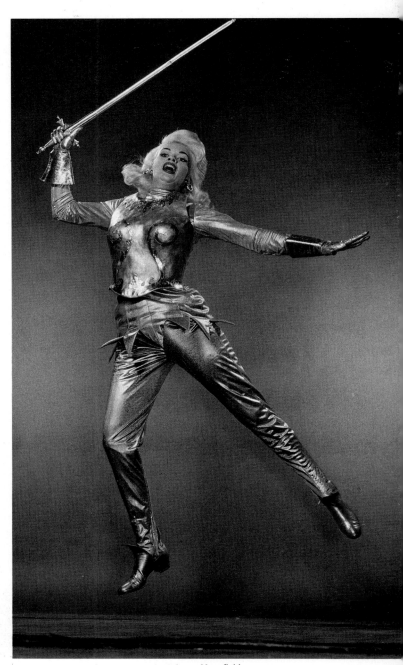

Jayne Mansfield

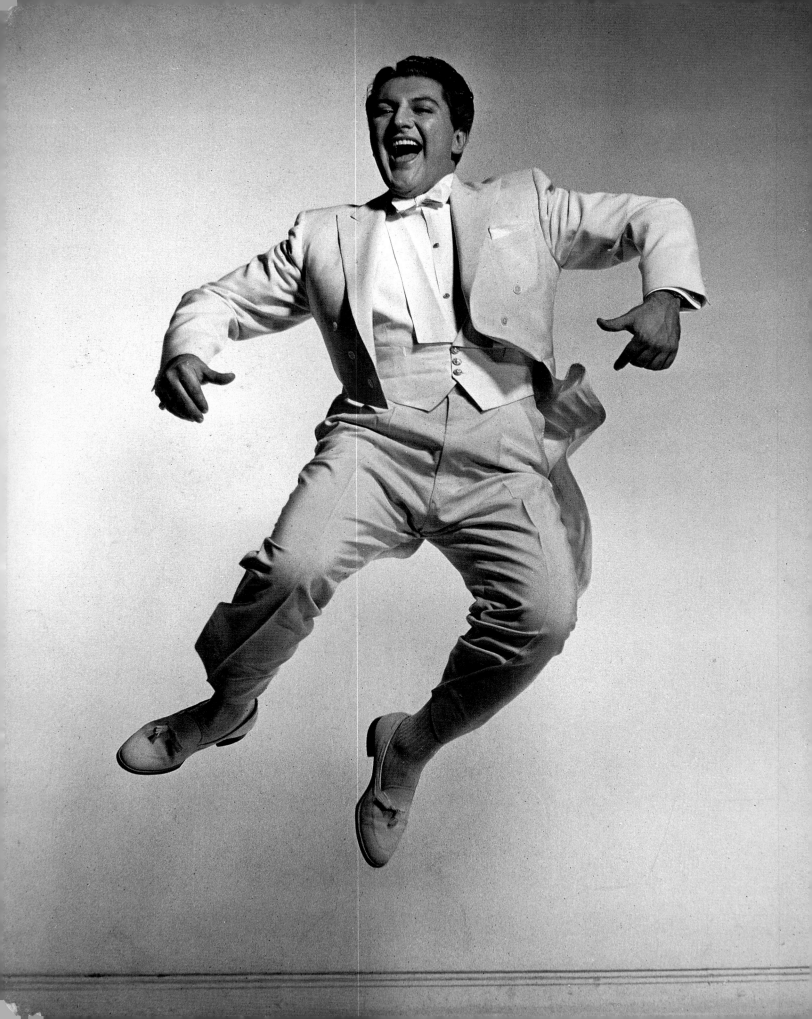

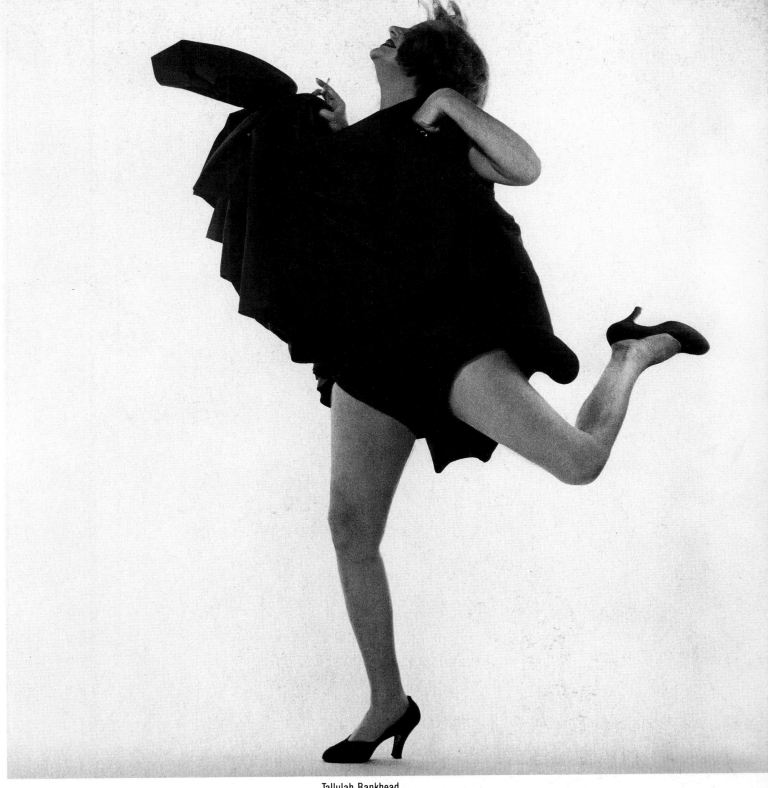

Tallulah Bankhead

\mathbf{W}hile Liberace floats like a cherub in the air, Tallulah's foot has no intention of leaving the ground. The great production and exhibition hide that the jump is only a make-believe of the great actress. (Or does it mean that Tallulah always keeps at least one foot on the ground?)

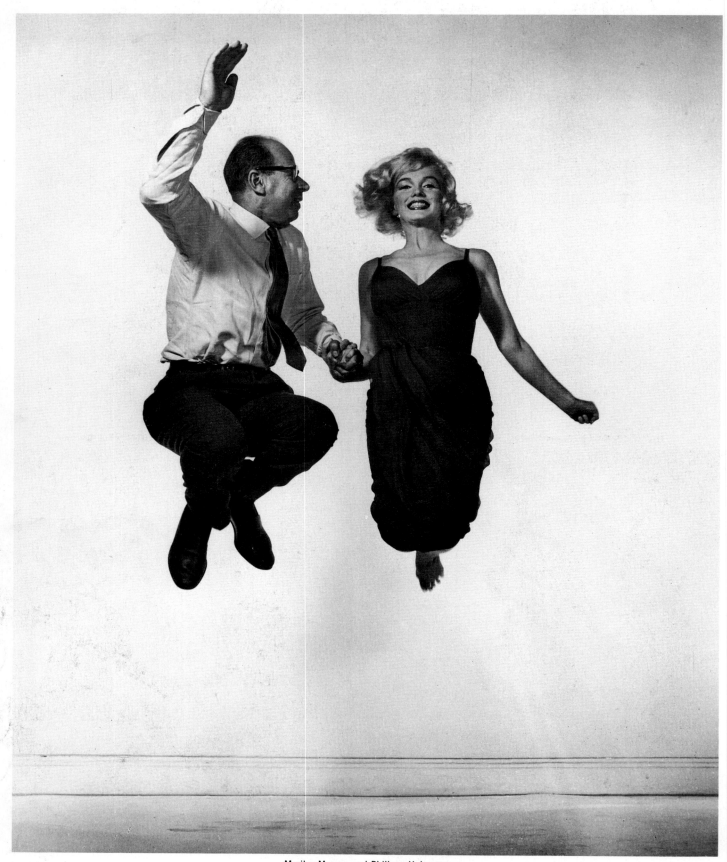

Marilyn Monroe and Philippe Halsman

The Author Jumps with His Subjects

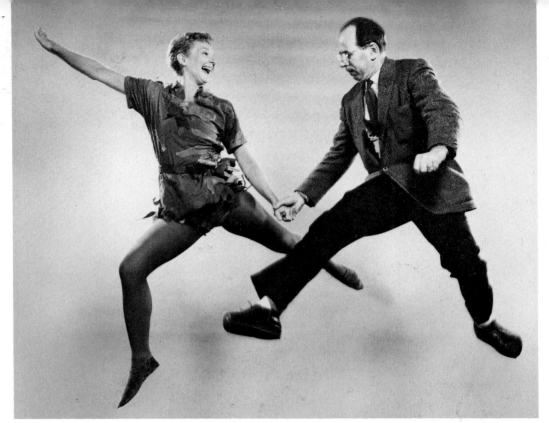

Mary Martin and Philippe Halsman

Grace Kelly and Philippe Halsman

Ray Bolger and Philippe Halsman

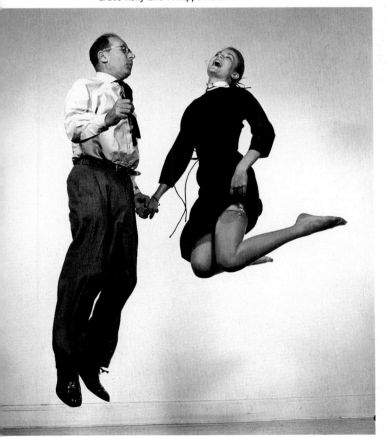

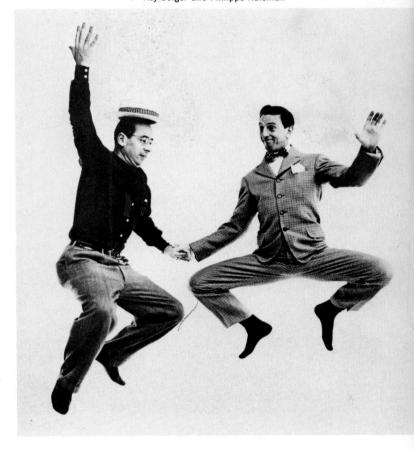

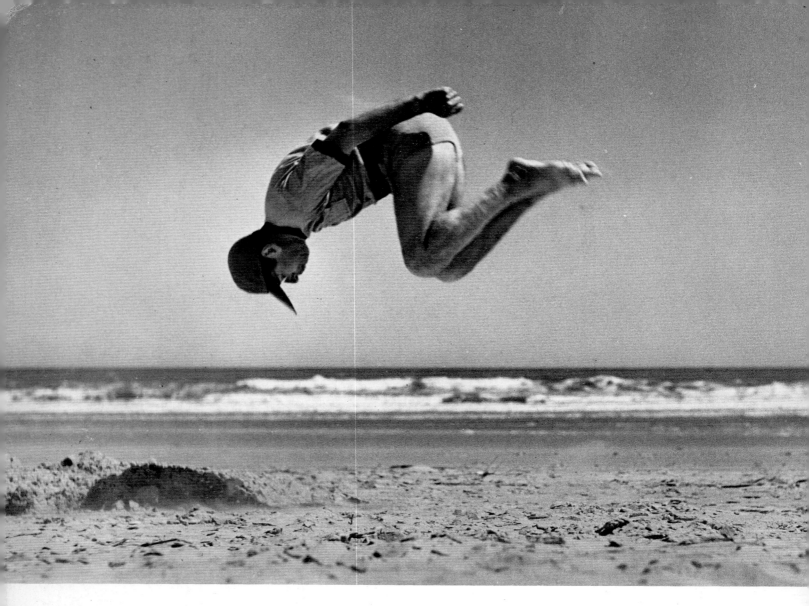

The Author

Philippe Halsman (1906–1979) was one of the great portrait photographers of our time. He had more *Life* magazine covers (101) to his credit than any other photographer, and three of his well-loved portraits—of Albert Einstein, Adlai Stevenson, and John Steinbeck—were used on United States postage stamps. His photograph of André Gide was used on a French stamp. His colleagues elected him as first president of the American Society of Magazine Photographers in 1944, and in 1958, he was chosen as one of the world's ten best photographers in an international poll. He was the recipient of the ASMP Life Achievement in Photography Award in 1975. Beginning in 1986, the ASMP instituted an annual Philippe Halsman Award for Photojournalism.

His work is represented in the permanent collections of numerous museums in the United States and abroad. Among his many one-man exhibitions was a retrospective that began at the International Center of Photography in New York in 1979 and will continue to tour the United States until 1988.

He was on the faculty of the Famous Photographers School, and from 1970 to 1979, he taught a seminar on psychological portraiture at The New School, New York.

Halsman Portraits, published in 1983, is a survey of his contribution to the art of (non-jumping) portraiture.